IMAGES
of America

ITALIAN
STATEN ISLAND

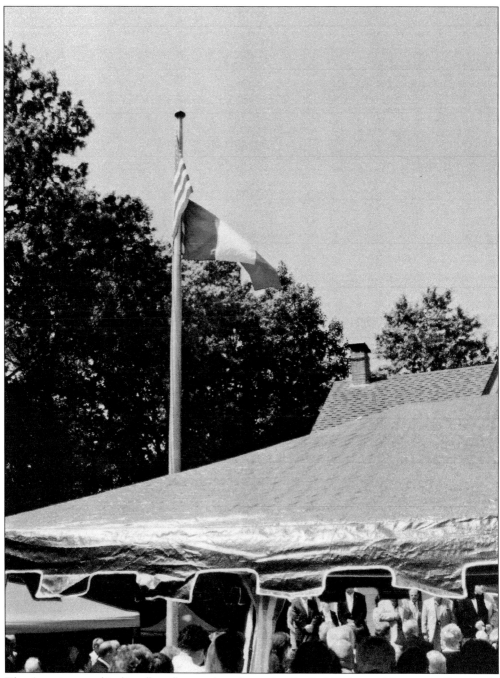

The American and Italian flags fly together above the Garibaldi-Meucci Museum in Rosebank, Staten Island. (Author's collection.)

ON THE COVER: The Giardino family enjoys a picnic in 1944 at Wolfe's Pond Park in Pleasant Plains. (Courtesy Stephanie Vierno.)

IMAGES
of America

ITALIAN
STATEN ISLAND

Andrew Paul Mele
Introduction by James P. Molinaro

ARCADIA
PUBLISHING

Published by Arcadia Publishing
Charleston, South Carolina

Printed in the United States of America

Library of Congress Control Number: 2009931279

For all general information contact Arcadia Publishing at:
Telephone 843-853-2070
Fax 843-853-0044
E-mail sales@arcadiapublishing.com
For customer service and orders:
Toll-Free 1-888-313-2665

Visit us on the Internet at www.arcadiapublishing.com

To my family:
my wife, Mildred,
Christine, Andrew, Alexandra,
and all the Neapolitans and Sicilians who put it together

CONTENTS

ACKNOWLEDGMENTS

I am deeply indebted to everyone who provided photographs and family stories for this publication, with special thanks to the Garibaldi-Meucci Museum in Rosebank; John Dabbene, president/chief executive officer; Nicole Fenton, director; and in particular, publicity coordinator Bonnie McCourt, who provided all the images for the historical first chapter.

I am grateful to the *Staten Island Advance* and editor Brian Laline, for the many photographs plucked from the newspaper's archives, and columnist Mike Azzara, whose advice and wonderful "Memories" column provided so much rich material.

I appreciate the efforts of Stephanie Vierno, who sought out photographs that were so instrumental in picturing Italian life on Staten Island.

Larry Anderson, chairman of the Staten Island Sports Hall of Fame, was extremely generous with his time and enormous collection of hall of fame material, revealing the many brilliant Italian American athletes from Staten Island.

Once again, Michelle Hascup was my computer guru, without whom this material would never make its way into print.

A special thank-you goes to Staten Island borough president James P. Molinaro, the sixth Italian American to hold that elected position, for agreeing to write the introduction to this volume.

INTRODUCTION

Staten Island is home to the largest percentage of Italian Americans in any congressional district in the country. As one of Staten Island's many proud Italian Americans, it is my great pleasure to recognize the positive impact Italians have had upon our borough.

The history of Staten Island is filled with influential Italians. The borough was discovered by Giovanni da Verrazano on April 17, 1524. Inventor Antonio Meucci made Staten Island his home in 1850. Italian freedom-fighter Giuseppe Garibaldi sought refuge here a few years later. Today the Garibaldi-Meucci Museum is maintained by the Order of the Sons of Italy and is dedicated to Italian American culture and heritage.

We have forged close ties with our Italian Sister City, Crespina, located in the region of Tuscany. Snug Harbor Cultural Center boasts a beautiful Tuscan garden, modeled after the Villa Gamberaia in Florence, Italy. Each year, the people of Staten Island celebrate their Italian American heritage with the festive Columbus Day parade.

Staten Islanders are immersed by Italian food, family, and culture. It is with great excitement that I see Staten Island's Italian heritage memorialized in this book.

—James P. Molinaro
Staten Island Borough President

James P. Molinaro was elected borough president of Staten Island in 2001. He was the first member of the Conservative Party to be elected to that position. Molinaro, the son of Italian immigrants, is a resident of Fort Wadsworth. He moved to Staten Island from Manhattan's Lower East Side in 1965. (Courtesy Office of the Borough President.)

One

ITALIANS MEET
STATEN ISLAND

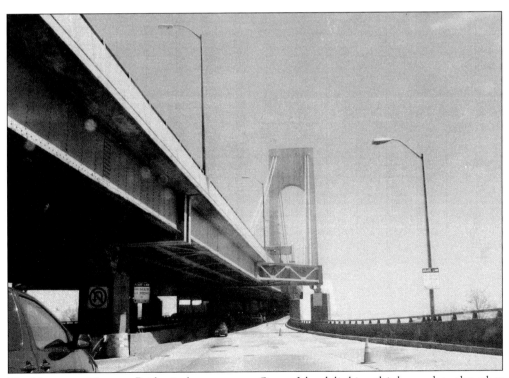

The Verrazano-Narrows Bridge is the gateway to Staten Island, linking this borough to the other four of New York City. It is named for Giovanni da Verrazzano, the Italian explorer who sailed for France and into New York Bay in 1524. Named in his honor, it was opened in 1964 and was the largest expansion bridge in the world at the time. At 4,260 feet with 12 lanes on 2 decks, its towers extend 680 feet into the sky. (Author's collection.)

The first four explorers to view the American mainland were all Italian navigators, but unlike Christopher Columbus, John Cabot, and Amerigo Vespucci before him, Giovanni da Verrazzano recognized that it was not part of Asia but a great new continent that separated the Eastern (Pacific) and Western Oceans. He landed at Cape Fear, North Carolina, on March 1, 1524, and explored the coastline north to Maine. He then anchored at Newfoundland before sailing for France. In New York, Verrazzano and his crew of 50 encountered Native Americans, whom he described as beautiful, generous, and friendly. His descriptions of the harbor and the surrounding countryside were the first ones of America. (Courtesy Garibaldi-Meucci Museum.)

Giuseppe Garibaldi was born in the city of Nizza, Italy, on July 4, 1807. He was a military and political figure and a great Italian patriot, lauded as the revolutionary leader who unified the country in the 1860s. He has been called the "Hero of the Two Worlds" for his military expeditions in both South America and Europe. Garibaldi's Staten Island connection began upon his arrival on July 30, 1850. He stayed at the home of his friend, inventor Antonio Meucci, in the Clifton section of Staten Island. While exiled, Garibaldi worked as a candle maker in his Meucci's plant. In their free time, the friends went hunting and fishing together on the island. Garibaldi stayed until April 1851. The cottage where he lived is listed on the National Register of Historic Places and now is preserved as the Garibaldi Memorial. During his stay in Staten Island, Garibaldi made formal application for American citizenship. (Courtesy Garibaldi-Meucci Museum.)

Upon his arrival in Staten Island aboard the English packet ship *Waterloo*, Giuseppe Garibaldi was detained, as all persons from abroad were, at the quarantine station in Rosebank. The red, white, and green flag of the Roman Republic was flown over the buildings in his honor. He lived in a second-floor bedroom in Antonio Meucci's home. During his stay on Staten Island, Garibaldi took walks along St. Mary's Avenue, shopped in the market in Stapleton, and went shooting in the woods on the Dongan Hills. (Author's collection.)

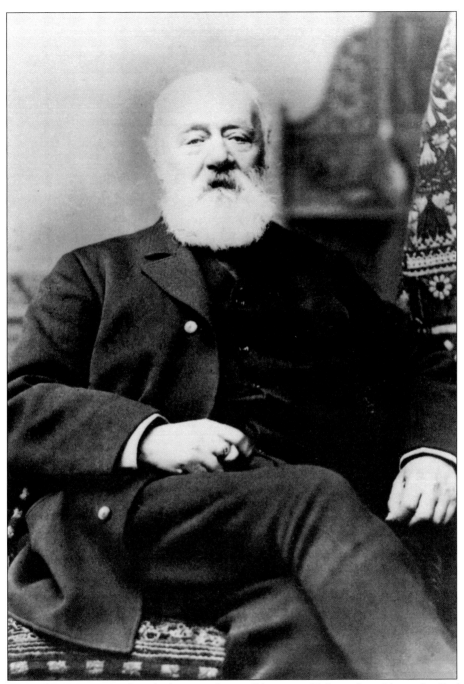

Meucci was busy inventing the telephone in the small house in Clifton when Alexander Graham Bell was just a child in Scotland. Meucci and his wife, Ester, left Italy amid 19th-century Italian uprisings and arrived in State Island in 1850. By 1852, Meucci had several telephone systems operating in his house and candle factory, as well as servicing the entire neighborhood. By 1862, he had developed more than 30 telephonic models but was never to get credit for a telephone patent, as fate stepped in and derailed his efforts. Bell registered his patent in 1876. (Courtesy Garibaldi-Meucci Museum.)

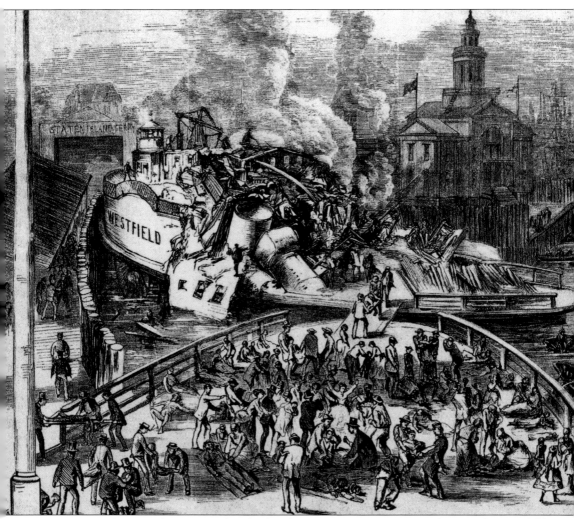

Returning from Manhattan one day, the ferryboat Antonio Meucci was riding on, the *Westfield*, exploded. A total of 100 people were killed in one of the greatest disasters of the era. Meucci suffered severe burns and was crippled. *Harper's Weekly* of August 12, 1871, described the scene: "There came a terrible crash, and in an instant the steamer was a wreck. The huge boiler had exploded." After depleting all of their funds for medical expenses, Meucci's wife had to sell his original telephone models to a junk dealer for $6. Unable to locate the models later on or raise the $250 needed to apply for a patent, Meucci sought financial backing. Unsuccessful, he was forced to watch Bell be declared the inventor of the telephone. (Courtesy Garibaldi-Meucci Museum.)

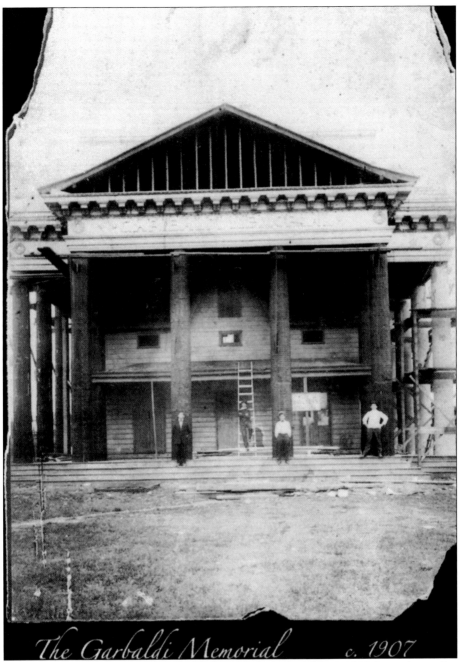

The Garibaldi Memorial c. 1907

The Garibaldi-Meucci Museum in Rosebank was dedicated on July 4, 1907. It was located at the site of the home where Meucci lived and operated a small candle factory. Giuseppe Garibaldi worked for his friend after being refused employment by the Post Office Department. Born in Florence in 1808, Meucci completed only grade school before his travels took he and his wife, Ester, to New York, where, from the little house on Staten Island, he continued work on his invention, the Telettrofono, as he called it in Italian. It was on June 11, 2002, that the U.S. Congress officially recognized the accomplishments of Meucci in the invention of the telephone. (Courtesy Garibaldi-Neucci Museum.)

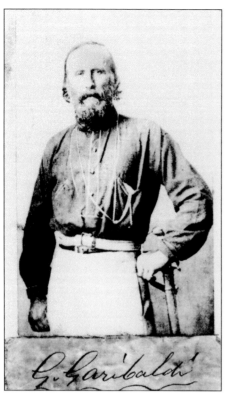

Giuseppe Garibaldi was despaired by living off of his friend's kindness, so he decided to go back to sea. He made his way to Peru, crossed the Pacific Ocean, and later returned to Boston. It was here that he was put in command of the ship *Commonwealth* and sailed to England. Seven years passed before Garibaldi, with 1,000 men, invaded Sicily, thereby precipitating the wars for the unification of Italy. Antonio Meucci fought legal battles to the end of his life in an effort to realize a patent for his telephone, but to no avail. He died in 1889. (Courtesy Garibaldi-Meucci Museum.)

In 1923, Italian Americans erected a monument to the inventor in Rosebank, Staten Island. In 1870, there were 2,891 Italians who immigrated to America; by the dawn of the 20th century, there were hundreds of thousands. (Author's collection.)

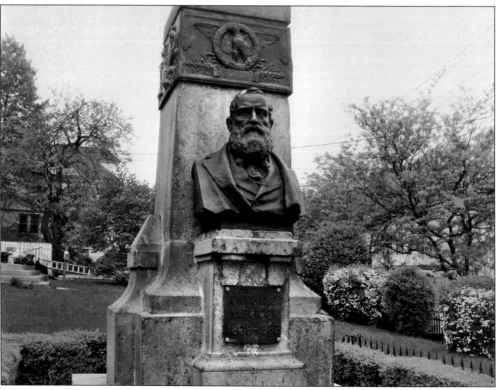

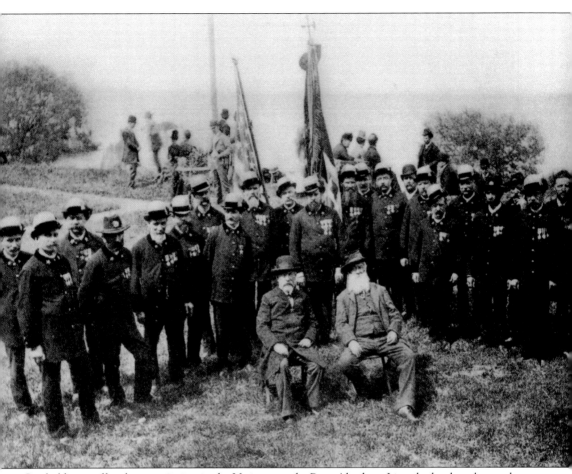

Garibaldi was offered a commission in the Union army by Pres. Abraham Lincoln, but he reluctantly refused, as the Italian unification wars had begun in Italy. There were several Italian units that fought in the Civil War, most notably the Garibaldi Guard. This photograph shows a group of Garibaldi veterans reunited at Rosebank. (Courtesy Garibaldi-Meucci Museum.)

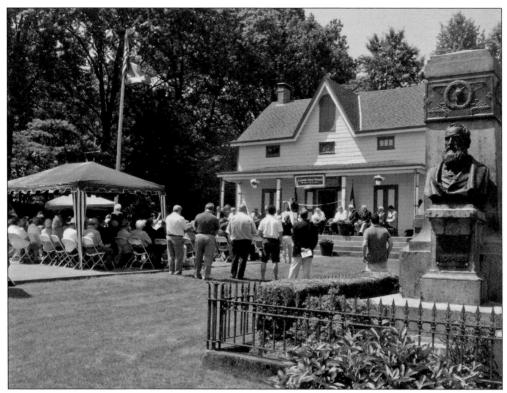

Recent renovations to the exterior of the Garibaldi-Meucci Museum climaxed with a rededication ceremony on July 11, 2009. In this photograph, John Dabbene, president/chief executive officer of the Garibaldi-Meucci Museum, addresses the audience. (Author's collection.)

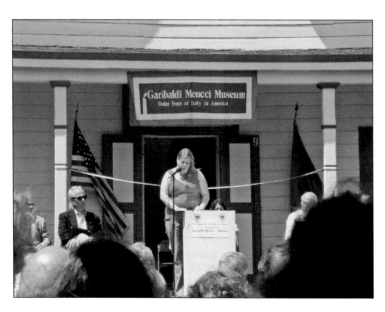

Melissa Ferrari-Santlofer, curator of the exhibit "If These Walls Could Talk," offers a historical background of Giuseppe Garibaldi and Antonio Meucci. The Order of the Sons of Italy is the owner and operator of the museum. (Author's collection.)

Two

IMMIGRATION AND SETTLEMENT

Concetta Sensale and Luigi Ferraiuolo were married in 1929. Concetta came from Naples when she was 17 years old, while Luigi was born in Lower Manhattan. Luigi was foreman on the Brooklyn waterfront during World War II and devised a way to load tanks onto ships that cut the loading time by 50 percent. They are shown with sons Ralph (left) and Frank. (Courtesy Frank Ferraiuolo.)

Immigrants crowded into Ellis Island. The Italians called it *l'isola delle lacrime*, the island of tears. The great wave of European immigration began in the late 19th and early 20th centuries. The exodus at the dawn of the 20th century when more than four million Italians emigrated was one of the greatest mass migrations in world history. The vast majority, like Francesca Cavallo, came out of a necessity for economic survival. (Author's collection.)

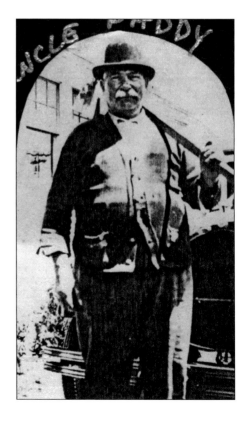

Pasquale Cava and Cavallo were of the Mezzogiono from southern Italy and Sicily. They were peasants for the most part; many who came to this country were illiterate. (Author's collection.)

Salvatore and Filomena Basile emigrated from Naples in the late 1920s, and the family made it to Staten Island by way of Brooklyn. Son Anthony remembers the house in Coney Island facing a pizzeria. "We would open the kitchen window and call for a pie," he said, "and Jerry the pizza guy would slide a hot pizza through the window and onto the kitchen table. It had to be the first drive-through pizza parlor." (Courtesy Anthony Basile.)

The author would like to pay homage to his own Italian ancestry by honoring his grandfather and namesake, Andrew Paul Mele. Pictured here in 1911, Mele was a New York City police officer for nearly 30 years. He and his wife, Mary, raised eight children and begat memories of love and kindness for the young children of this Italian American family. (Author's collection.)

Mary Ruisi (left) came to the United States from Palermo in the first decade of the 20th century. Like so many of the early immigrants, she found it necessary to leave her eldest child behind in Sicily. The young girl shown with Mary is unidentified, possibly one of her daughters. (Author's collection.)

Giuseppe Ruisi (below) stayed in Italy where he lived, worked, married, and raised a family in the city of Bologna. When he visited his American relatives in 1949, he made two requests, to take a ride on the Staten Island ferry and to visit the Garibaldi-Meucci Museum in Rosebank. These wishes were granted and a pleasant visit with kin sent Ruisi home a happy man. (Author's collection.)

Actor Robert Loggia was born on Staten Island on January 3, 1930. An outstanding athlete, Loggia played baseball, football, and basketball at New Dorp High School and attended Wagner College on a football scholarship. He is a member of the New Dorp High School Hall of Fame. Both of Loggia's parents emigrated from Sicily. Loggia was nominated for an Emmy for his role in the television series *Mancuso, FBI,* and he received a Best Supporting Actor Oscar nomination for his part in the film *The Jagged Edge* in 1985. Proud of his Italian heritage, Loggia notes that his father was in his 20s when he came to this country. "He came because he wanted a better life for his children," said Loggia. (Courtesy Robert Loggia.)

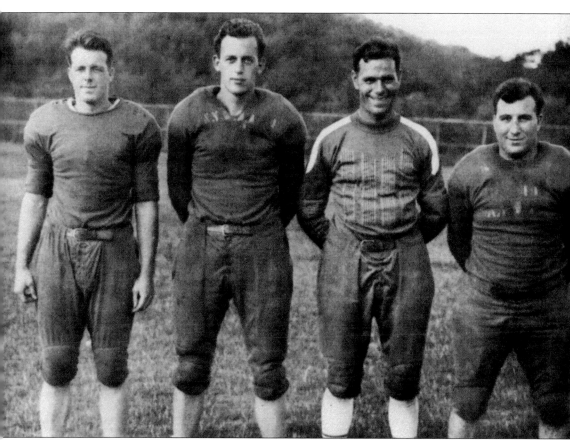

Pictured here as teammates at New York University, Andy Barberi (far right) and Sal Somma (second from right) both grew up on Staten Island. The two are indelibly linked as legendary high school coaches in island lore, where they perpetuated Staten Island sports history at New Dorp and Curtis High Schools. Barberi also played with the Brooklyn Dodgers professional football team. It was at New York University that Barberi blocked and Somma kicked the winning point in a victory over Vince Lombardi and Fordham University's "Seven Blocks of Granite" in the 1930s. Both are members of the Staten Island Sports Hall of Fame. (Courtesy Staten Island Sports Hall of Fame.)

Maria and Francesco Destro came to the United States from Sicily. Maria's home was in Palermo, while Francesco came from Agrigento. They came to Staten Island's New Springville section in 1992. (Courtesy Maria Destro.)

Never far removed from their Italian heritage, the Destros cling to an old tradition. They pack tomatoes in jars for sauce, or gravy, so-called depending upon which area of Italy people originated. Here Francesco (right), with the help of family friend Natalie Calabro, carry on this ritual in the Destro garage. (Courtesy Maria Destro.)

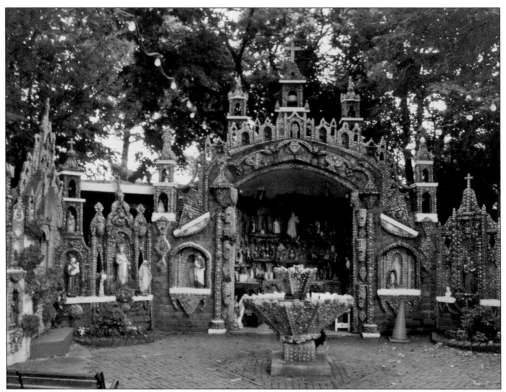

The Our Lady of Mount Carmel Society was formed in 1903, and its first president was Joseph A. Palma, the father of the future borough president Joseph Palma. Vito Louis Russo, along with 46 other society members, began work on the shrine and grotto dedicated to Our Lady of Mount Carmel. It took 25 years to complete, and Russo oversaw the project until his death in 1954. In 2001, the shrine was included in the New York and National Registers of Historic Places. (Author's collection.)

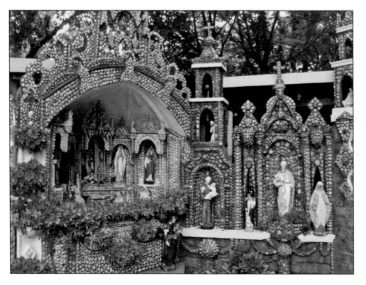

There are more than 70 statues in the grotto. The main shrine is 20 feet high and 50 feet long. Joseph Sciorra, in his study of Rosebank called it the "biggest indigenous Roman Catholic shrine in this city, and the best example of that art form in New York." (Author's collection.)

Devoted to Our Lady of Mount Carmel while in his native Italy, Russo vowed that should he get to America, he would build a shrine to honor her. Beyond even his expectations, a magnificent monument arose enhanced by thousands of hand polished stones, many from South Beach. Two of his grandsons are Staten Islanders. Vito Russo, pictured, helps to maintain the shrine. (Author's collection.)

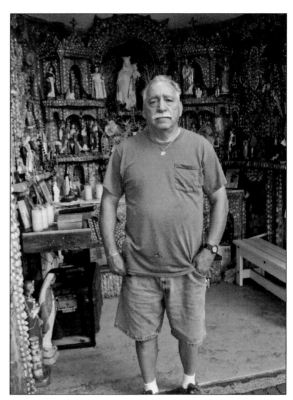

Future singer and actor Gianni Russo is pictured at two years of age at his grandpa's shrine. (Courtesy Gianni Russo International LLC.)

Honoring saints with festivals has long been an Italian tradition. San Gandolfo, patron saint of Polizzi Generoso in the Sicilian province of Palermo, is one. People from Catania celebrated Sant' Agata, who, according to legend, saved the city from destruction by lava during an eruption of Mount Etna. Probably the most notable is the San Gennera Festival, held each year in Manhattan's Little Italy to venerate the patron saint of Naples. In Staten Island's Rosebank section, a feast and a procession of reverence for Our Lady of Mount Carmel is held each July. Entertainment celebrity Gianni Russo greets residences at the 106th anniversary feast. (Courtesy Staten Island Advance, 2009. All rights Reserved. Reprinted with permission.)

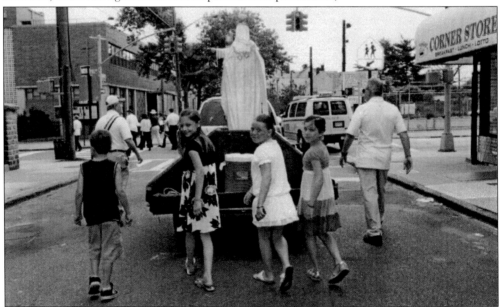

A statute of Our Lady of Mount Carmel is borne through the streets of Rosebank. Joseph Barone, 7; Gabrielle Zukowski, 11; Hallie Barone, 10; and Madison Zukowski, 10, march behind the statue. (Courtesy Staten Island Advance, 2009. All rights reserved. Reprinted with permission.)

Al Fabbri (right), shown with Sal Somma, will always be known as the "father of football" on Staten Island. He kept the game alive during the Depression years while compiling an indelible record of achievement at Curtis High School. His teams were 59-9 with three ties from 1928 to 1936. He coached a generation of future coaches and greats like Somma and Andy Barberi. Fabbri is a member of Staten Island's Sports Hall of Fame. (Courtesy Staten Island Sports Hall of Fame.)

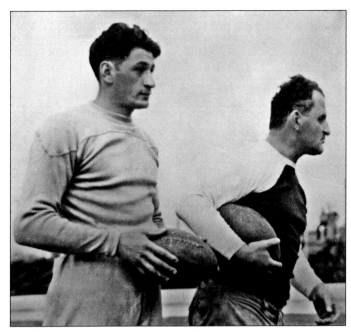

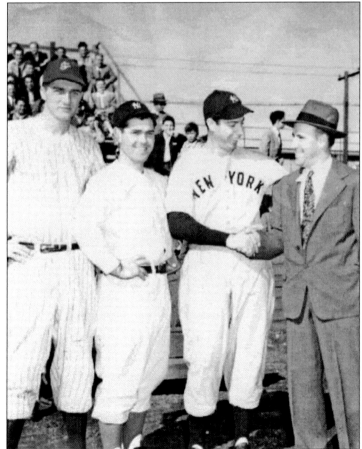

Another hall of famer is Lou Marli. A friend to Staten Island sports, Marli was a benefactor to track and baseball programs throughout the island. It was Marli who brought a team of servicemen to Staten Island in 1946 that included Joe DiMaggio, shown shaking hands with Marli. They squared off against a Staten Island club, with major leaguers Bobby Thomson, Hank Majeski, and Karl Drews among them. (Courtesy Staten Island Sports Hall of Fame.)

One of the oldest and most formidable families on Staten Island is in reality a combination of four families in one prodigious clan. Diego Ferrara (pictured on the right with his son Louis on left) arrived in America in 1909 and by 1911 settled in Mariner's Harbor, Staten Island. From that point the proliferation of the Ferrara, Lambert, Giovinazzo, and Moliterni families began in earnest. Ferrara emigrated from Acoma, Sicily, and his wife was from Messina. (Courtesy Al Lambert.)

Two of the Ferrara children are seen in the photograph. Louis Ferrara is standing at right, and Mary Ferrara is seated at left. The other two pictured are unidentified. (Courtesy Al Lambert.)

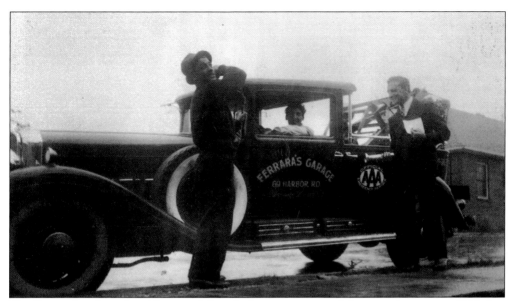

The Ferrara brothers, Lou, Dom, and Angelo, began an automobile repair business in 1927 that evolved into a Toyota dealership. The family has remained in the automobile business for 82 years. Angelo is seen behind the wheel, with Dom Lambert on right, and an unidentified man on left. (Courtesy Al Lambert.)

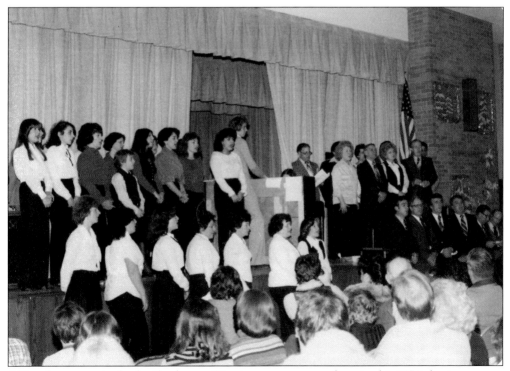

Al Lambert organized a family chorus, 50 voices strong, to perform in this 1978 charity concert at St. Michael's in Mariner's Harbor. (Courtesy Al Lambert.)

Jack Furnari, born in Mariners Harbor, attended Curtis High School and Pace University. His mother, Angie, and Jane Ferrara were sisters; another link in the Ferrara-Lambert family chain. Furnari went to work for the *Staten Island Advance* in 1969 and retired in 2006 as marketing manager. He then embarked on a new career, not unusual for this family, as a singer. He has appeared at the Staten Island Hotel, the Staaten, and other island locations noted for food and entertainment. His repertoire features Italian classics and arias in addition to Broadway blockbusters. (Courtesy Jack Furnari.)

Al Lambert continues to widen the family horizons. His recent marriage to Lenore Cibelli brought the Cibellis into the family fold. Richard and Mary Cibelli (left) owned Island Surgical on Hylan Boulevard in New Dorp for 35 years. (Courtesy Al Lambert.)

Joseph A. Palma was the first of six Italian Americans to hold the position of Staten Island borough president, and he served from 1934 to 1945. Distinguished Italians, the family of de Palma was a member of the aristocracy in Chiaramonte, Province of Potenza, Italy. Joseph's father, J. Andrea de Palma, came to the New York area in 1875, where Joseph was born in 1889. Brought to Staten Island as an infant, he grew up in Rosebank. His father founded St. Joseph's Church in 1902 and was the organizer and first president of the Our Lady of Mount Carmel Society. Joseph was appointed an operative in the U.S. Secret Service in 1915, where he served with distinction until his retirement in 1929. (Courtesy Staten Island Advance, 1940. All rights reserved. Reprinted with permission.)

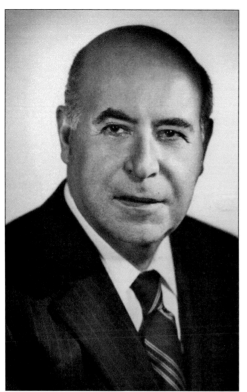

Albert V. Maniscalco (left), a Democrat, served as borough president of Staten Island from 1954 to 1965. It was during his time in office that the Verrazano-Narrows Bridge was opened. Born in Manhattan, he moved to Staten Island when he was nine. Maniscalco is credited with saving the Greenbelt, one of the island's great natural areas. (Courtesy Staten Island Advance, 1970. All rights reserved. Reprinted with permission.)

Guy Victor Molinari was born in Manhattan on November 23, 1928, but came to Staten Island as a boy and attended New Dorp High School, where he graduated in 1945. He earned a degree from Wagner College and served in the U.S. Marine Corps during the Korean War. A Republican, Molinari was a member of the House of Representatives and served as Staten Island borough president from 1990 to 2001. (Courtesy Staten Island Advance, 2009. All rights reserved. Reprinted with permission.)

Anthony R. Gaeta was born in West Brighten and graduated from McKee High School in 1945. Educated at New York and Cornell Universities, Gaeta began a political career in 1949. He served as borough president from 1977 to 1984. (Courtesy Staten Island Advance, 1982. All rights reserved. Reprinted with permission.)

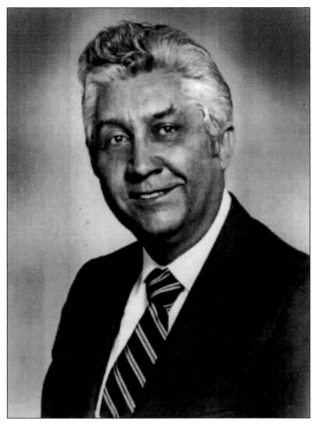

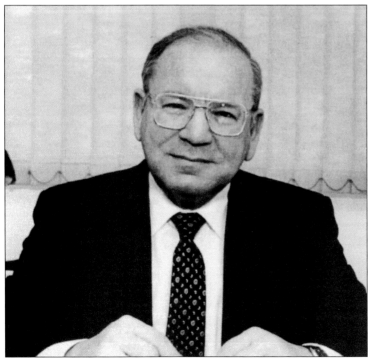

Ralph J. Lamberti is a member of the Democratic Party and held the office of borough president from 1984 to 1989. Lamberti's grandparents were both born in Sorrento, Italy, and landed in Staten Island in 1918. Lamberti also served as vice president of Staten Island University Hospital. (Courtesy Staten Island Advance, 2007. All rights reserved. Reprinted with permission.)

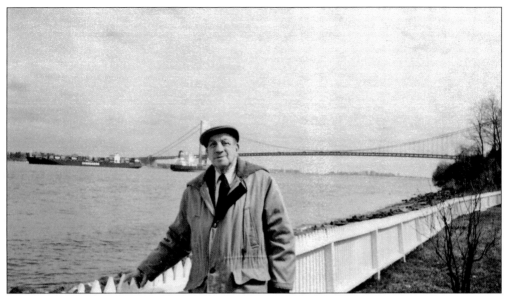

Stephen Acunto was born in Rosebank at 9 Hylan Boulevard across from what is now the Alice Austen House and Museum. Although Acunto worked for the law enforcement staff of the Westchester County Sheriff's Office for 34 years, he is best known as a boxer and boxing instructor. (Courtesy Stephen Acunto.)

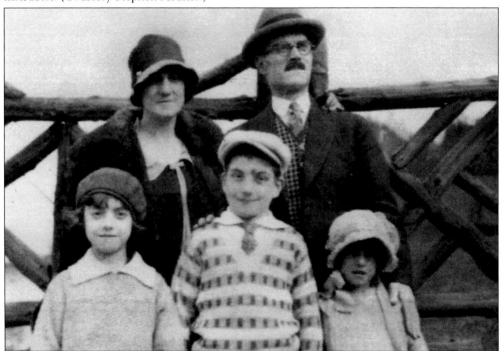

Acunto's grandfather arrived from Naples, and like so many Italian immigrants, he landed in Manhattan before settling in Staten Island. Acunto said his grandfather was "so proud to be an American," that if he died abroad, he wanted his body returned to the United States. "He died in Naples," Acunto said, "but he was buried in Moravian Cemetery." Acunto is pictured with his mother, Loretta; father, Stephen; and sisters Dina (left) and Gloria (right). (Courtesy Stephen Acunto.)

Since 1981, Acunto has been dedicated to teaching students of boxing the basic fundamentals and techniques with an emphasis on safety at Westchester Community College in the only accredited boxing course in the country. He and partner Rocky Marciano formed the American Association for the Improvement of Boxing in 1969. Acunto fought exhibitions against some of the best fighters of the era. "They were real fights," he said, "only there were no decisions." He once fought six rounds with lightweight champ Lou Ambers. "We grew up in a different world. A beautiful world." Acunto is proud of his Italian heritage. "Our people that came here were proud and hard working," he said. "They only wanted a chance." (Courtesy Stephen Acunto.)

When boxing was big on Staten Island, there were few fighters bigger than a Rosebank kid named Mickey Cangro. Staten Island had its own champs in the 1920s and 1930s, and Cangro held both the lightweight and the welterweight crowns. At age 19, he defeated Willy Curry at the Staten Island Coliseum in April 1922. The coliseum, located at Port Richmond Square, was opened by the Brighten Boxing Club in December 1921. Cangro was described as a rugged, relentless slugger in the ring. Tragically, the young fighter died at the age of 26 on May 2, 1929, days after he submitted to a blood transfusion to save his sister's life. (Courtesy Staten Island Advance, 2009. All rights reserved. Reprinted with permission.)

Umberto Percunia and Geromina Bonnanini were married in 1939 and left for America in the same year. They came from a town called Rio Maggiore near Genoa. (Courtesy Christopher Percunia.)

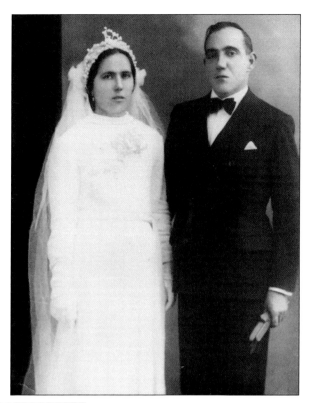

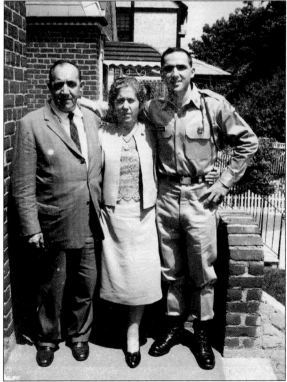

The Percunia's son Angelo Christopher served in Vietnam with the Signal Corp of the U.S. Army in the mid-1960s. (Courtesy Christopher Percunia.)

Traditions are paramount with Italian people. One of the strongest is the Christmas Eve dinner. Primarily featuring numerous courses of fish, stemming from years of the church's ban on eating meat on specific days, including Christmas Eve, the day is a celebration of family as well. The Ferraiuolo family gathers for a 1977 Christmas Eve celebration. (Courtesy Frank Ferraiuolo.)

In a traditional Italian home, Sunday is family day. Great food, some good wine, which at one time was always homemade, and a bevy of relatives to visit with are the norm. The Ferraiuolo family enjoy a typical Sunday gathering in the 1960s. (Courtesy Frank Ferraiuolo.)

Three

WAR AND PEACE

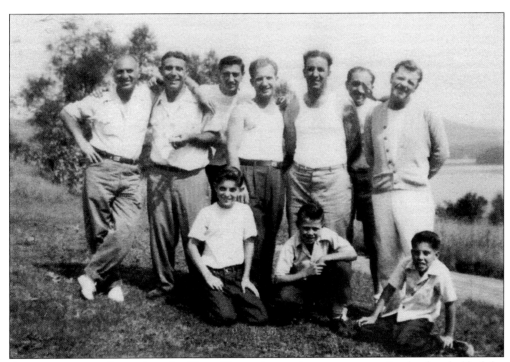

Americans were subjected to the Great Depression and two great wars in the first half of the 20th century. Italian Americans served their country well through some catastrophic times and celebrated victories with their fellow Americans. The men and boys of the Giardino family revel in the postwar era with an outing in 1948. (Courtesy Stephanie Vierno.)

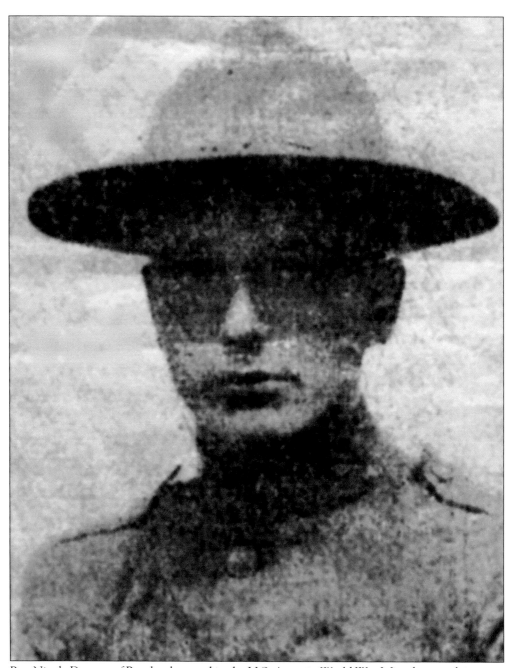

Pvt. Nicola Damato of Rosebank served in the U.S. Army in World War I. In a letter to his niece, dated April 27, 1918, Damato wrote, "This soldier life is not so bad after all because once you get used to it things run pretty smooth." On September 25, 1918, Damato was killed by shell fire at North Thiaucourt, France. He died heroically while serving his country. Born in 1894, Damato was 24 years old when he died. There is a playground in Rosebank named for him, and for many years, there was held a gun salute at the site in his honor each Memorial Day. Damato was the first Staten Islander to be killed in World War I. (Courtesy Rita Sandberg.)

by Rostan

Nick Troianiello still resides where he grew up in Mariners Harbor. He is a retired firefighter who attended Port Richmond High School and joined the U.S. Marine Corps the day after graduation. His parents, Vincenzo and Angelina, met on the boat coming here from Italy and were the first couple to be married in St. Michael's Church. Troianiello was one of six children—four sons and two daughters. His memories include time spent on a tiny island in the South Pacific. Troianiello served as an automatic rifleman with the Third Marine Division on Iwo Jima in World War II. The 83-year-old recalls the battle as "living hell. We ate together, we lived together, we died together." Just 18 days after the raising of the flag on Mount Suribachi, he was hit with shrapnel in the forearm and right eye while firing from a trench. "We all went through it together," he says now, "I was just one of the guys." (Courtesy Nick Troianiello.)

Donald (Donato) Baldassare was born in Abruzzi, Italy, and came to America at three years of age. He grew up in West Brighten, Staten Island. Baldassare had his training at New London, Connecticut, and served with the U.S. Coast Guard in the 1940s. He was ship cook aboard *Lightship* 99. Baldassare has the best of two worlds—he is a citizen of the United States and also of his native Italy. (Courtesy Donald Baldassare.)

Angelo Ferrara of Mariners Harbor did his tour of duty in World War II in the European theater. Stationed in Germany, Ferrara was delighted to learn that his brother Dominick, also in the army, was just 50 miles away. He commandeered a jeep and sought out his brother. The drive was made more difficult because the Germans had changed the road signs and he had to navigate by compass. He found his brother in the latrine, but that did not lessen the joy each felt knowing that the other was alive and well. In 1943, Ferrara was married to the former Theresa Lambert. (Courtesy Al Lambert.)

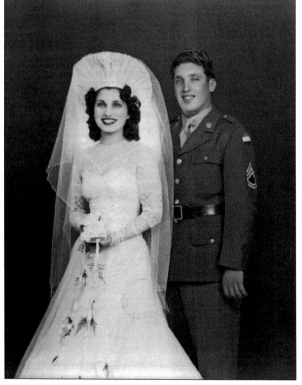

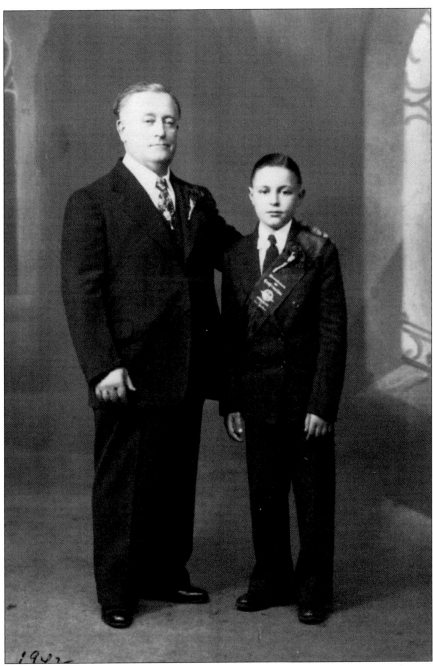

With the onset of World War II, the government chose to isolate Americans and immigrants whose heritage was from an Axis nation. Many were interred in camps around the country, and some were at Ellis Island. Some 600,000 immigrants were forced to register as "enemy aliens." The sad irony of this is that so many had sons in combat zones fighting and dying for the country that labeled their parents. This 1942 photograph is of the confirmation of 10-year-old Frank Ferraiuolo and his godfather, Anthony Pontillo. Pontillo emigrated from Terre de Greco, Italy, near Naples in the 1930s and was now an enemy alien and had to report regularly to authorities. (Courtesy Frank Ferraiuolo.)

During the early stages of World War II, there were an estimated 2,000 Italian prisoners of war held on Staten Island in Stapleton and Fox Hill. Mariners Harbor had 200 to 300 Italian soldiers, and more were kept at Fort Wadsworth. Most were captured in North Africa. Rather than become part of the German army, they preferred surrendering to the Americans. On Sunday afternoons, the prisoners were allowed to mingle with the populace at places like South Beach. Sue D'Ermilio (seated between two prisoners of war in this 1944 photograph) remembers the officer on her right as Franco. "He was very educated and spoke English very well," she recalled. Franco was from Florence. After the summer, the ladies visited the prisoners at the fort and brought them home-cooked meals. (Courtesy Sue D'Ermilio.)

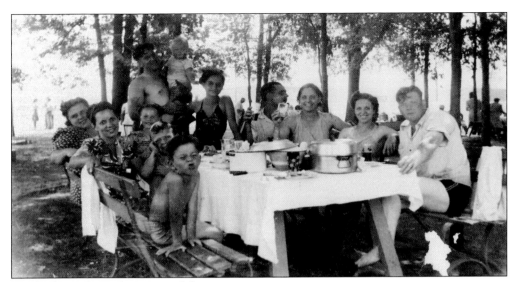

On the home front, Americans did their part amid the rationing, civil defense drills, and working in defense plants. Many Staten Island women went to work at jobs directly linked to the war effort. However, some degree of normalcy was retained. Here the Giardino family enjoys a family picnic in Wolfe's Pond Park in Pleasant Plains. (Courtesy Stephanie Vierno.)

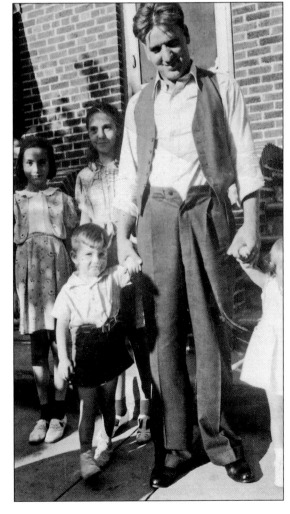

Umberto Giardino is pictured with his children in 1943. (Courtesy Stephanie Vierno.)

Dom Lambert and Jane Ferrara were married in 1942 and lived in Mariners Harbor. Lambert worked as a maître d' at the Nelson terrace in Great Kills and also at the Manor House on Manor Road for 15 years. Jane's family has been noted in the automobile business on Staten Island for three generations. (Courtesy Al Lambert.)

Music, particularly the sounds of the big bands, helped to keep the country afloat during these critical times, and where there is music, there are Italians. Lou DeTaranto joined the Tommy Dorsey Orchestra more than 60 years ago, playing clarinet and saxophone. DeTaranto and his swing band are still at it, performing at such Staten Island locations as the St. George Theater.

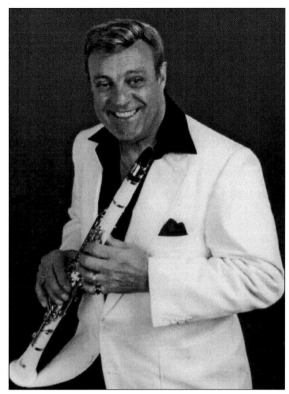

One of the longest-running bands on the island is the Richmondaires. The band featured such local luminaries as Bobby Gamboa on drums, Jerry Gee (Giovinazzo) on baritone sax, and George Monte as a trombonist who did some time with the Benny Goodman and Tommy Dorsey Orchestras. Willie Filmeno played tenor sax, and Pat Gambardella was on bass.

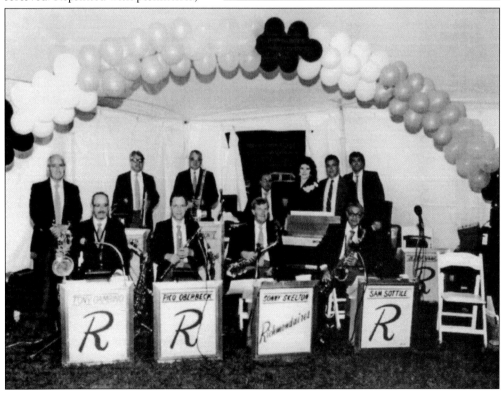

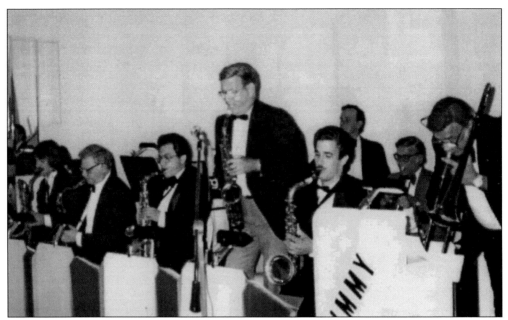

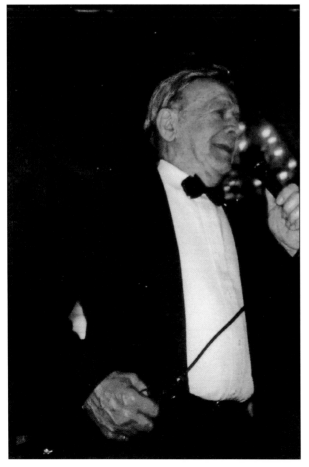

Jimmy Febb (Fevelo) of West Brighten organized a band in 1948 that played the great music of the big band era. He played trombone (far right), and also included were his brothers John (woodwind), Joseph (drums), and Nicholas (trumpet and vocals). The brothers were all World War II veterans. Jim and Nick played in the Special Services band opposite the Glen Miller Orchestra in England. (Courtesy Staten Island Advance. All rights reserved. Reprinted with Permission.)

Nick Febb is the only living member of the band. Retired after 44 years with the telephone company, he resides in Castleton Corners. At age 85, he still plays from time to time. He raised six children, including John, who owns the SunnySide School for Music, Drama, and Dance on Clove Road. Mark and Joseph Febb, both musicians, play regularly. Nick feels blessed to have such a family bond through music. (Courtesy John Febb.)

Almondo Conte came to America in 1948 before returning to his home in Santo Tommaso in the Abruzzi region of Italy to marry Angela and bring her back to the United States in 1952. It was "bad in Italy following the war," Almondo relates. "Living under two dictatorships, first Mussolini and then the Germans was hell." Angela explained how her husband hid under a large rock in a cave to hide from the Germans' work parties. America meant a chance for a new life and to have a job. He wanted to work. "I never asked for charity from Uncle Sam," he said. (Courtesy the Conte family.)

The Contes celebrated their 50th wedding anniversary and 50th year in America in the same year. They lived in Brooklyn for 35 years before coming to Tottenville, Staten Island, where they have resided for 15 years. (Courtesy Conte family.)

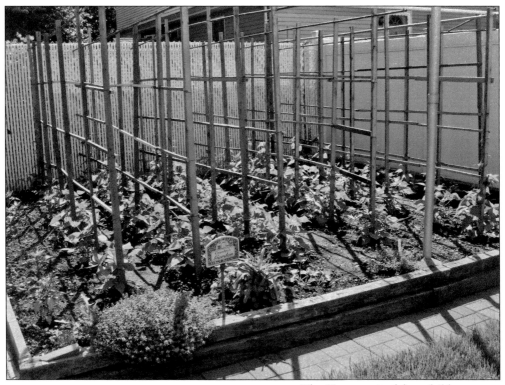

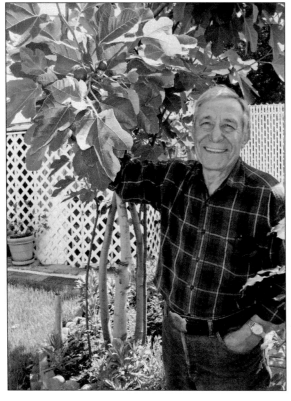

The Contes raised four children and still keep busy. They grow tomatoes, jar the sauce, and make homemade wine. Almondo Conte is attentive to his beautiful garden—a touch of Italy—with fig trees and vegetables and an array of beautiful flowers. At 82 years old, he will not rest. "What I got," he says, "I worked for. That's what I believe." (Courtesy Conte family.)

An era in sports history frozen in time is the period of semiprofessional baseball in America. Flourishing in the 1920s, 1930s, and 1940s, it took its last gasps just after World War II. Legendary teams like the Brooklyn Bushwicks and Negro League clubs often came to Staten Island. Venues like Pros Oval in West Brighten and Weissglass Stadium housed such Staten Islanders as George Genevese. (Courtesy Staten Island Sports Hall of Fame.)

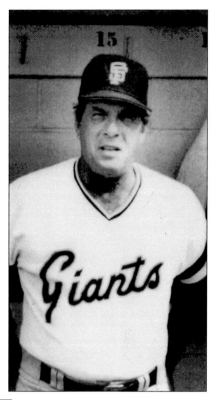

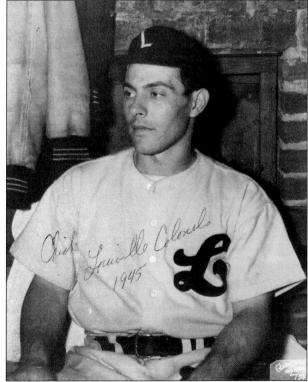

Chick Genevese, brother of George, is pictured here. Both had successful careers as Major League Baseball scouts, and both are enshrined in the Staten Island Sports Hall of Fame. (Courtesy Staten Island Sports Hall of Fame.)

Ball clubs like the Richmond Red Sox and the Concord Groves dotted the island in the semiprofessional era. Most notable were the Gulf Oilers and the Staten Island Yankees. Gabe Rispoli ran the Yankees, and Sebastian "Sonny" Grasso (pictured on the left) starred. Grasso played for three seasons in the minor league system of the Boston Braves before a successful career as coach at the College of Staten Island. He is a hall of famer, class of 2003. (Courtesy Staten Island Sports Hall of Fame.)

Weissglass Stadium was a major sports arena on Staten Island during the first half of the 20th century. Named Sisco Park for the Staten Island Shipbuilding Company who owned the property, it was later changed to Weissglass Stadium when the milk company took over the location. In between, it was called Braybrooks Stadium for William Braybrooks, who ran the Gulf Oilers. The scene of many exciting sports events, this 1954 photograph shows a classic football game between rivals Curtis High School and New Dorp High School on Thanksgiving Day. Curtis defeated New Dorp 19-12. (Courtesy Staten Island Sports Hall of Fame.)

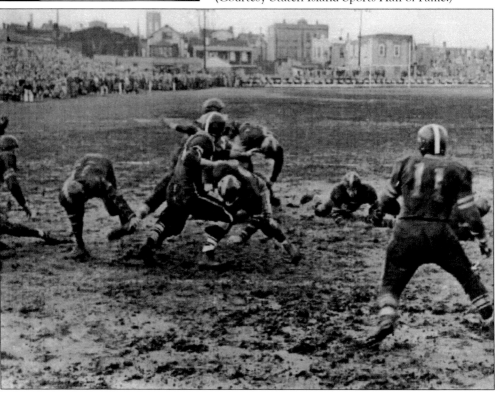

Four

THOSE SOMETIMES FABULOUS 1950s

Pres. Dwight David Eisenhower was reelected to the White House in 1956, and his landslide victory carried with it a future island political legend. John Marchi won a seat in the state senate, and he was a fixture in state politics for the next 50 years. Marchi was a lifelong Staten Islander, born in Brighten Heights. He retired in 2006, one month shy of his 85th birthday. (Courtesy Staten Island Advance, 1942. All rights reserved. Reprinted with permission.)

Sen. John Marchi shocked New York's political world in 1969 when he defeated Mayor John Lindsey in the Republican primary but lost the general election. He and Maria Luisa were married for 61 years. His accomplishments on behalf of Staten Island were many. He was instrumental in saving the city from bankruptcy in the mid-1970s, was a force in the development of the College of Staten Island and Snug Harbor Cultural Center, and was instrumental in shutting down the Fresh Kills landfill. (Courtesy Staten Island Advance, 2006. (All rights reserved. Reprinted with permission.)

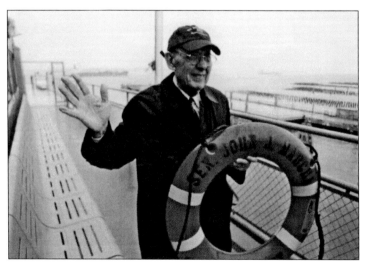

In 2004, a ferry boat was named for Marchi. It has been said of Marchi that his actions were principled and ethical. Marchi died in 2009. As one legislator remarked of the senator, "It was always Staten Island first. That will be his legacy, and he did it with class." (Courtesy Staten Island Advance, 2005. All rights reserved. Reprinted with permission.)

From Bunker Hill to Baghdad, Italian Americans stood shoulder to shoulder with their fellow Americans in defending the nation's liberty. In mid-April 1953, Cpl. Faust Sofo stood at the foot of a piece of Korean terrain called Pork Chop Hill and began to scale it amid a barrage of heavy artillery fire. Sofo (right in this photograph, with an unidentified friend) was a rifleman in G Company in the army's 7th Division, and their job was to take and hold the hill even as the peace talks at Panmunjom dragged listlessly on. From atop the hill, Sofo recalls an enemy attack under cover of darkness and the glow cast by rounds of mortar fire revealing flickering glimpses of the Chinese attack. "They looked like ants coming up the hill," Faust recalls. The casualties were enormous. Of 180 men in G Company, only 11 returned. "I was lucky," Sofo said in a paradigm of understatement. (Courtesy Faust Sofo.)

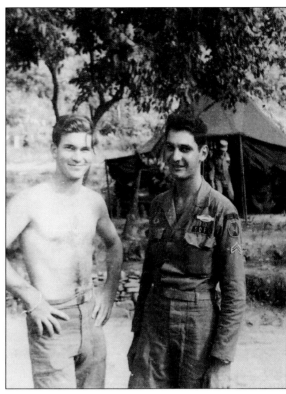

Pictured is Sofo of Prince's Bay. (Author's collection.)

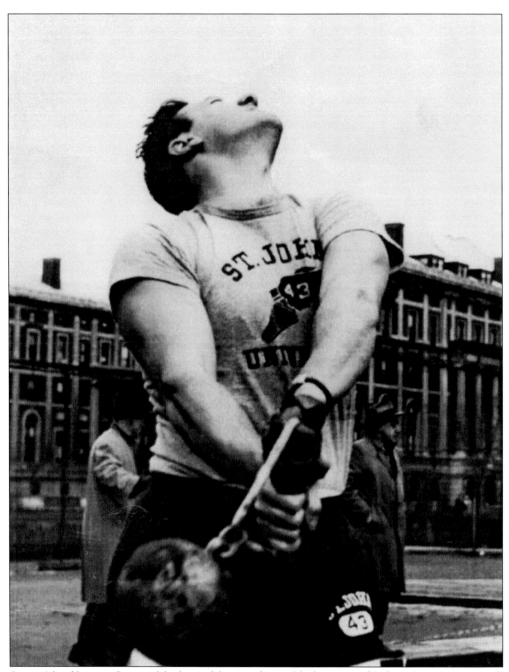

Staten Island boasts of some of the best athletes in the world of sports, and Italian Americans are well represented in this august group. Vic Gattullo has been executive director of the Staten Island Zoo and president of the American Parkinson Disease Association, but like the mighty Thor of myth, Gattullo is best remembered for his strength and size, dating back to his days in high school. While at Curtis High School, Gattullo, at six foot three, was pressed into service as a hammer thrower. He threw the 35-pound weight as a student at St. John's University at the Metropolitan Intercollegiate Field Events in 1956. He also held the title of Knights of Columbus shot put champion. (Courtesy Staten Island Advance, 1956. All rights reserved. Reprinted with permission.)

Len Carrie is pictured around 1957 in his early years as an entertainer. (Courtesy Len Carrie.)

Len Carrie and the Krackerjacks was a musical aggregation put together by Leonard Caramante of West Brighten. The quintessential entertainer; singer, musician, comic, and emcee, Carrie's career took him to the top of his realm. A second banana with Spike Jones and his City Slickers, Carrie played the top spots in the country and appeared on the television show Club Oasis as a key member of the "Band that Played for Fun." Carrie loved live television and was a natural as a sight-gag comic. He remained actively on stage until well into his 70s. (Courtesy Len Carrie.)

Hey Andy
You are not to
be sneezed at
God Bless!

Joey Faye

The great burlesque comedian Joey Faye was born Joseph Palladino in 1909 on the Lower East Side of Manhattan, the son of an immigrant barber. Faye lived in Great Kills and spent 65 years in show business. He worked in every medium but is best known for his roles as second banana to Phil Silvers on Broadway. "His legacy is that he was really the last of the burlesque clowns," said Tony Randall, another costar. For several years, he was the bunch of grapes in the Fruit of the Loom television commercials. An extremely generous and extraordinary man, Faye will be remembered as the epitome of the great era of burlesque comics. (Author's collection.)

Teresa and Saverio Vacca are seen in this 1915 photograph taken in Bitonto, Italy. Little Tommaso (front, right) emigrated to America and to Staten Island in 1955. (Courtesy Theresa Percunia.)

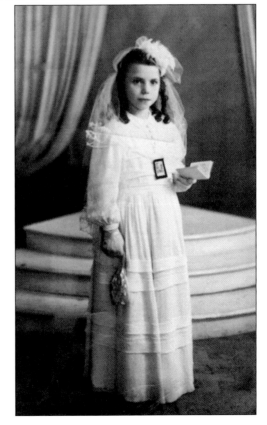

Tommaso's daughter Theresa was just a child when she arrived in the United States and grew up in Port Richmond. Married to Angelo Christopher Percunia in 1967, the couple raised two children on Staten Island, and they currently reside in Great Kills. (Courtesy Theresa Percunia.)

Larry Napp was an American League umpire for 24 baseball seasons, where he worked in 3,609 games. He umpired in eight no-hit games, including Don Larsen's perfect game against the Brooklyn Dodgers in the 1956 World Series, where he umpired at third base. Born Larry Albert Napadano, he was a star athlete at Lincoln High School in Brooklyn, and he later boxed and played baseball professionally. He was also a highly regarded boxing referee and a chief fitness instructor in the navy during World War II. Stationed on Staten Island, he and his wife moved there after the war and raised a son, Larry Jr. They stayed on the island until 1962, when the couple relocated to Plantation, Florida. Napp is a member of the Staten Island Sports Hall of Fame. (Courtesy Staten Island Sports Hall of Fame.)

The 1950s represented a period of change in most areas of American life. Music, by 1954, had certainly affected enough of a difference to know that something entirely new was in the offing. People were a bit more affluent, and young men like Frank Ferraiuolo buzzed around in a 1946 Ford. (Courtesy Frank Ferraiuolo.)

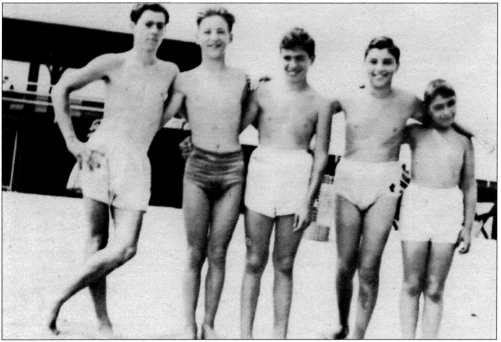

At South Beach in 1950, future *Staten Island Advance* columnist Mike Azzara (left), a native of South Beach, is seen with summer friend Bobby Cassotto, later to be known as singing star Bobby Darin (second from left). The boys are with friends, from left to right, Hugo, Jack Morano, and Ronnie. (Courtesy Staten Island Advance, 1950. All rights reserved. Reprinted with permission.)

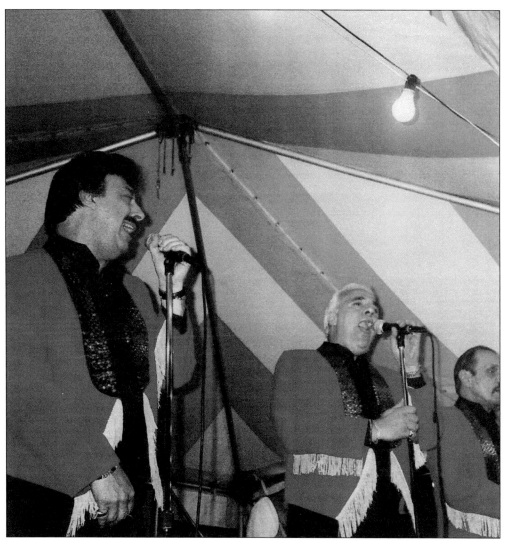

In South Beach, doo-wop group was formed in 1958 by Vito Picone. It included Arthur Venosa, Frank Tardogano, Carmen Romano, and James Mochella. The group often performed under the boardwalk near their homes. Vito and the Elegants hit the charts in a big way with a song called "Little Star." The recording reached the top of the R&B and pop charts in September 1958. After splitting up, the group reunited in the early 1970s and continues to perform in the nostalgia-oriented present. They can be seen annually at the San Gennaro Festival in Manhattan's Little Italy. Their recording of "Little Star" has become one of the most popular and identifying records of the 1950s rock and roll era. (Courtesy Vito Picone.)

Pictured is Rocco and Loreto's Deli in Annadale. (Author's collection.)

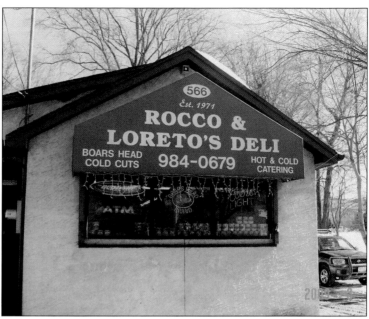

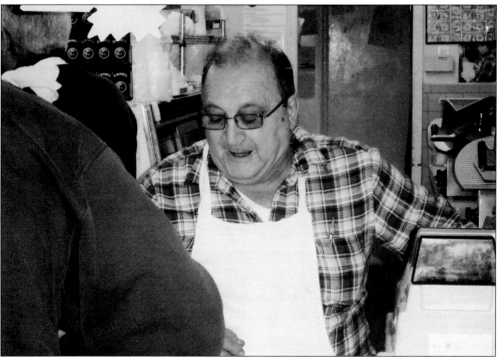

Rocco Balestriese is an Old World artisan, a cabinet maker from Ischia, Italy, near Naples. He came to New York in 1954 and brought with him the work ethic inherent in his heritage. Working all day with a firm in Manhattan, Balestriese toiled each day to midnight in a grocery store. In 1972, he opened Rocco and Loreto's Deli in Annadale. "It's a family business," he said, but it is also a family of customers that frequent Rocco and Loreto's Deli. It is a place of warmth and nostalgia for those old neighborhood stores and wistful memories of family and friends. The old cabinet maker is still very much the artisan. (Author's collection.)

Gabe Perillo is an artist who has painted the greatest athletes of all time. His work is known world wide. A Staten Islander, Perillo, as a World War II veteran, studied art under the GI bill. He was influenced by a guest instructor at the Cartoonists and Illustrators School named Norman Rockwell. "I was fascinated by the way he created and composed in his mind," Perillo said. Boxing was his favorite topic. Perillo painted 18 covers for *Ring Magazine*. His work was featured on the ESPN special *50 Greatest Athletes of the Century*, as well as the series *SportsCentury* and *Classic Moments in Sports*. (Courtesy Gabe Perillo Jr.)

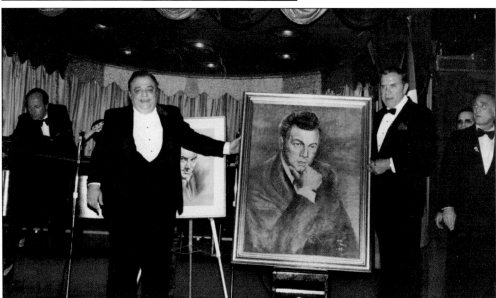

What is not as well known about Perillo is his wonderful singing voice. He took voice lessons and sang in more than 20 operas with the Amatto Opera Company and the Long Island Opera Company. In 1983, he was the recipient of the Mario Lanza award. "After 20 years of listening to singers," said Nick Petrella, president of the Mario lanza Institute, "I have to say that Gabe Perillo sounded the closest to Mario Lanza that I have ever heard." Perillo (left) and Petrella are pictured with a portrait of Mario Lanza painted by Perillo. (Courtesy Gabe Perillo Jr.)

In addition to all of his artistic achievements, Perillo was also a boxer, winning the navy Golden Gloves title in 1944 in the 112-pound class. However, painting was his best love. In his 70s, when asked if he might consider retiring, he said, "I'll keep going until I can no longer dip the brush in the paint." True to his word, Perillo continued to create great art until his death in 2002. While Gabe Perillo Jr. does not paint or sing, he did inherit his father's love for boxing. On March 22, 1974, he won the Golden Gloves 106-pound division with a third-round technical knockout over Ricardo Torres. This photograph shows Perillo Jr. delivering a hard right hand to the face of Torres. He fought internationally for the U.S. team and served as a police officer for 20 years. He has also taught boxing at the Cromwell Center in St. George on Staten Island. In many ways, it is like father, like son. (Courtesy Gabe Perillo Jr.)

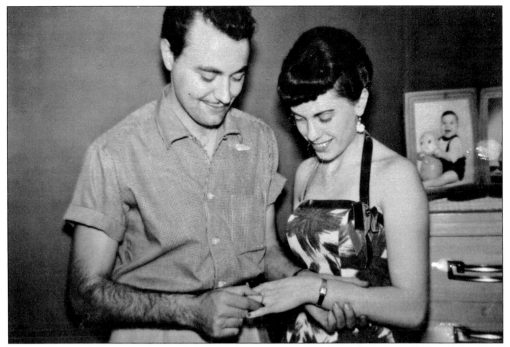

Listening to Italian singer Jerry Vale's ardently romantic rendition of a song called "Innamorata" (meaning sweetheart in Italian) brings one to the brink of *memoria . . . bella memoria*. Frank Ferriauolo and Jean Spina were engaged in June 1955 and married in 1956. (Courtesy Frank Ferriavulo.)

"Irish" Eddie Jordan was a welterweight boxer when he met Theresa Flenda. Over the years, it was her home cooking that turned Jordan into an Italian food lover. "Before we were married," said Jordan, "the only Italian cooking for me was Chef Boyardee." (Courtesy Eddie Jordan.)

Frank J. Paulo is sworn in as a judge of surrogate court in 1961. Paulo began his judicial career in 1954 when he was appointed as a municipal court judge by Mayor Robert F. Wagner. Born in Rosebank, he graduated in 1932 from Curtis High School and earned degrees from Fordham University and Harvard Law School. He was called a quiet but fair man and an outstanding legal scholar and judge. He died in 1981. (Courtesy Staten Island Advance, 1992. All rights reserved. Reprinted with permission.)

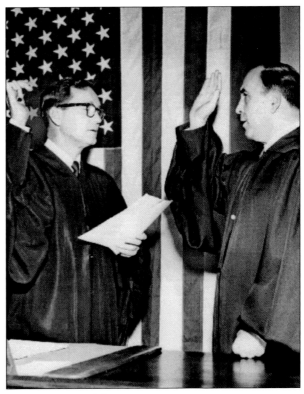

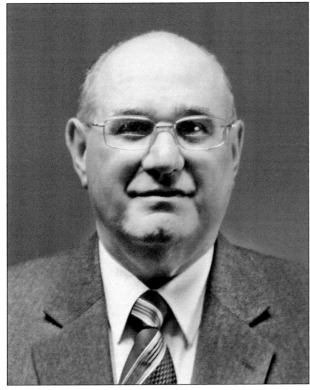

John Dabbene is the president/chief executive officer of the Garibaldi-Meucci Museum in Rosebank. Born in Brooklyn, he attended New York Community College and Polytechnic Institute and worked as an electrical designer for Con Edison for 43 years. Dabbene has been a leader in waging battles against negative images of Italians. In 1982, he persuaded the United States Military Academy at West Point to include Italian in its language program. He led the fight to stop the U.S. Postal Service from incredibly issuing a "Godfather" stamp as a tribute to Italian Americans. In June 2009, he was the recipient of the prestigious Bene Emeritus award given by the Order Sons of Italy in America. (Courtesy John Dabbene.)

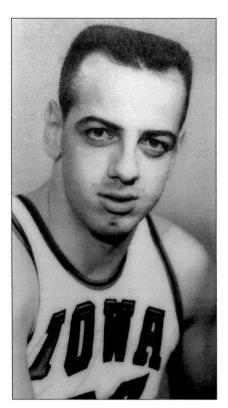

Nick Bruno was a two-sport star at Port Richmond High School and the University of Iowa. The first on Staten Island to score 1,000 points, he also scored 50 points in a single game. He was the 1957 Sandlot Baseball Alliance All-Star MVP. His inspiring credo to youth is, "A book in one hand, a ball in the other." (Courtesy Staten Island Sports Hall of Fame.)

Ben Sarullo has been a football coach at Monsignor Farrell High School for over 20 years. An all-city lineman at New Dorp High and captain of the Wagner College team during an undefeated season in 1960, he coached the Farrell Lions to consecutive titles in 2000 and 2001. Both Sarillo and Bruno are members of the Staten Island Sports Hall of Fame. (Courtesy Staten Island Sports Hall of Fame.)

Five

THE NEW WAVE

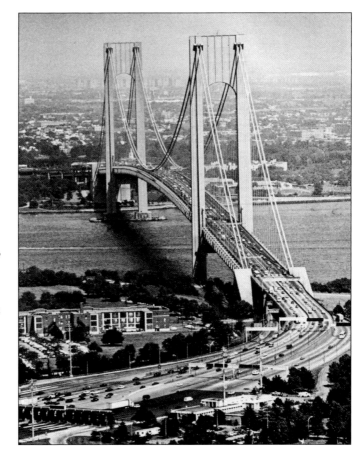

The new wave of Staten Island immigration was swept in with the opening of the Verrazano-Narrows Bridge in 1964. Once again, a spirited people ventured across a body of water, and this time they came primarily from Brooklyn. In 1960, the island population was 222,000. By 2000, it had doubled to 443,728. Italian Americans were in the vanguard of the new wave. (Courtesy Staten Island Advance. All rights reserved. Reprinted with permission.)

From Brooklyn with love; the new wave coming in from the borough of Brooklyn was overwhelmingly Italian. They left the urban landscape that they had grown up in. (Author's collection.)

These new immigrants settled comfortably into what was a rural atmosphere in the 1960s. It was a new experience for these city dwellers, where pheasants and rabbits ran across the lawns. The area ultimately became decidedly suburban. (Author's collection.)

Frank J. Illiano used the Belt Parkway as his exodus route from the Sheepshead Bay section of Brooklyn to begin a new life in Staten Island. The owner and operator of Sweetbrook Nursery and Garden Center in Eltingville since 1990, Illiano has thrived as a Staten Islander. (Author's collection.)

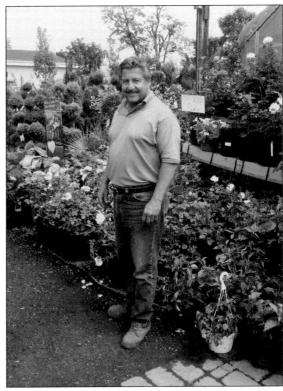

Al Marchese came from Red Hook and has lived on Staten Island for more than 40 years. An avid golfer, Marchese can be found on the links at La Tourette Golf Course almost daily, as he shoots in the 70s. Like so many of the Brooklynites, the Marcheses have lived longer on Staten Island now than they did in Brooklyn. (Author's collection.)

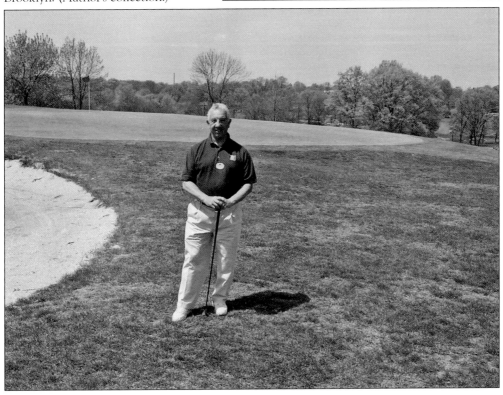

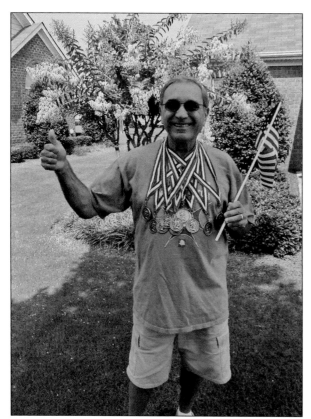

Tom Siracusa moved his family to Eltingville in December 1964 barely a month after the opening of the Verrazano-Narrows Bridge. "We were one of the first moving vans over the bridge," Siracusa said. He and and his wife, Angela, lived on Staten Island for 34 years. Always the athlete, he played softball for teams like Sail Inn on Sunday mornings and Lees Tavern on weekday evenings. Continuing his winning ways as a senior citizen, Siracusa displays the 10 medals he won in a recent Senior Olympics tournament. (Courtesy Tom Siracusa.)

The Siracusa twins, Debra (left) and Denise (right), appeared in the christening scene of the movie *The Godfather*. Many scenes were filmed on Staten Island. The christening was filmed at Mount Loretto on Hylan Boulevard in Prince's Bay. (Courtesy Tom Siracusa.)

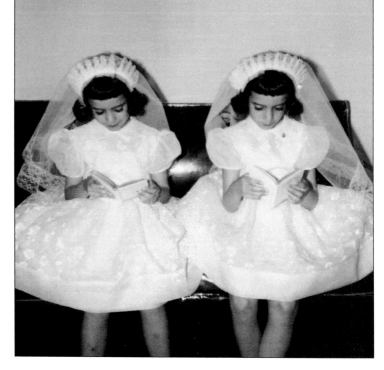

Tom Siracusa maintained his homegrown vegetable garden after relocating to Roswell, Georgia. After giving some tomatoes to a neighbor, the neighbor responded with thanks and said the tomatoes were great on their BLT sandwiches, but Tom had another fate in mind for his prize creations. "First," he said, "they should be added to a large loaf of Italian bread. Then you put prosciutto, Genoa salami, and provolone, all in layers. The cold cuts come from Tumminello's Salumari in Great Kills. While enjoying this repast with friends like Fat Dom, Pee Wee and Jack the Wig, you have a CD playing in the background. Bocelli singing 'Mama;' Pavoratti singing 'O Sole Mio;' and Jimmy Roselli doing his rendition of 'When Your Old Wedding Ring Was New.' There is no better fate for a home grown Italian tomato." (Courtesy Tom Siracusa.)

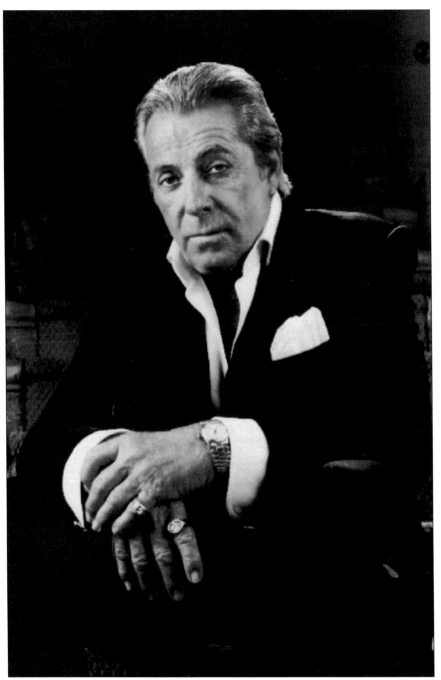

The movie industry has a long Staten Island history. In the 1890s, a studio on Sand Lane in South Beach filmed more than 100 Western movies before it closed in 1914. Since then, a great many movie scenes and music videos have been filmed on the island. The most notable was Francis Ford Coppola's epic *The Godfather*. Staten Island singer and actor Gianni Russo portrayed Carlo Rizzo in the film. Russo has appeared in more than 40 films but is known also as a singing star. The crooner travels the country performing the music that has had such an influence on his life. (Courtesy Gianni Russo International LLC.)

Jim Ursillo was a hard throwing left-handed pitcher who blew away the hitters. Signing with the New York Mets, Ursillo went as high as Triple A baseball in the minor leagues before an arm injury curtailed a promising career. From the New Utrecht section of Brooklyn, he and his family have lived in Great Kills for over 40 years. (Courtesy Jim Ursillo.)

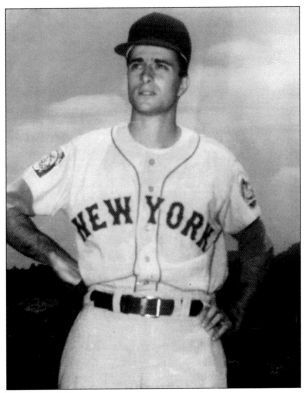

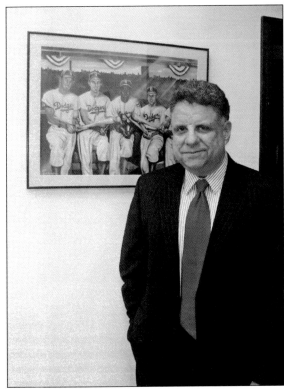

John D. Famulari is an attorney who maintains an office in Bay Ridge where he grew up. Raising a family on Staten Island for the past 29 years, Famulari now shares his practice with his son Dominic. Ever loyal to his Brooklyn Dodgers, their office is aglow with Dodger memories. (Author's collection.)

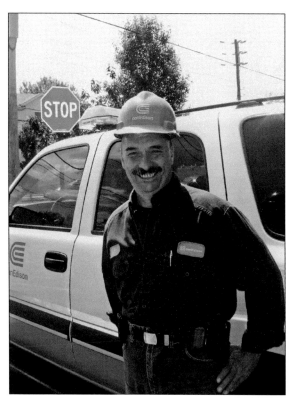

Vito Vavallo works for the Emergency Response Unit of Con Edison. He responds to emergency situations and acts as a liaison with police and fire departments. Vavallo's job is safety. "That's our first concern," he says. (Author's collection.)

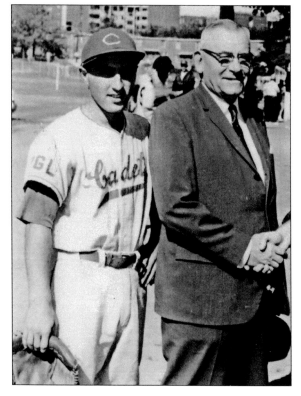

Matt Galante came out of the golden age of New York City sandlot baseball as teammate to Joe Torre and Rico Petrocelli. Galante played Triple A baseball before turning to managing in the minor leagues. He has spent more than 20 years as a Major League Baseball coach and as of 2009 works in the front office of the Houston Astros. A longtime resident of Staten Island, Galante was inducted into the Staten Island Sports Hall of Fame in 2007. Here he is shown as a Brooklyn teen. The man on the right is an unidentified sandlot league official. (Courtesy Jim McElroy.)

The "home boy" keeps singing. Here Al Lambert, Staten Island's resident music man, poses with comedian Pat Cooper (right). Lambert has a long and accomplished history entertaining Staten Islanders. He grew up in Mariners Harbor and at PS 44 began singing in front of an audience when in the second grade. (Courtesy Al Lambert.)

Lambert began to sing professionally at 12 years old and has been a byword in entertainment on Staten Island ever since. He has also appeared at such popular spots as Dangerfield's in Manhattan, owned by comic Rodney Dangerfield. (Courtesy Al Lambert.)

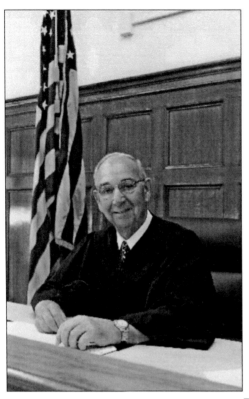

Justice Louis "Wally" Sangiorgio was born in Dongan Hills. A 1947 graduate of New Dorp High School, Sangiorgio served in the navy and was admitted to the bar in 1955 after graduating from Brooklyn Law School. In 1978 he won election to the Civil Court. Elected to the Supreme Court in 1981, he gained a reputation as a well-respected jurist and a scholarly presence on the bench. Justice Sangiorgio was appointed first supervising judge of the State Supreme Court in 1987. (Courtesy Staten Island Advance. All rights reserved. Reprinted with permission.)

Judge Vito J. Titone was appointed to the Court of Appeals by Gov. Mario M. Cuomo in 1985. Born in Brooklyn, Titone moved to Staten Island in 1957. He was elected to the state supreme court in 1968 and appointed to the appellate court by Gov. Hugh Carey in 1975. The first Staten Islander appointed to the appellate court, he was referred to as "a pathfinder in the Staten Island Legal Community." (Courtesy Staten Island Advance. All rights reserved. Reprinted with permission.)

The community of Rosebank in the northeast section of Staten Island is anchored by the presence of Giuseppe Garibaldi and Antonio Meucci. The Italian population there began to develop in 1890 with the first great immigration and has grown to the point where it has become truly an Italian community. Established in 1902, St. Joseph's Church was the first Italian parish on the island. The founder and pastor was Rev. Paolo Iacomino (1902–1905). The Reverend Msgr. Anthony Catoggio (pictured) was born in Armento, Italy, in 1876 and ordained in Rome in 1899. He arrived in America in 1905 after submitting his name as a volunteer to help Italian immigrants in the new land. He stayed for 53 years and served the parish and the community as pastor until 1959. (Courtesy St. Joseph's Church.)

St. Joseph's Church gets a new bell in 1912. It was a six ton cast-iron bell from Vickers Foundry of Sheffield, England. (Courtesy St. Joseph's Church.)

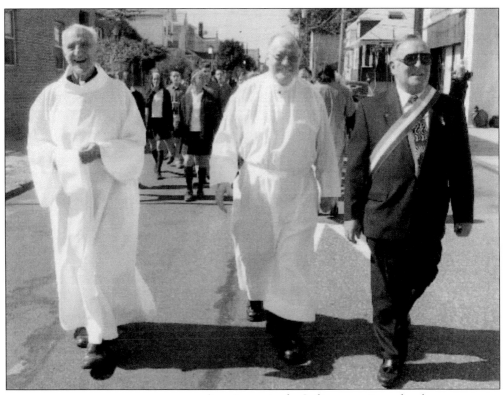

A mainstay in the Italian experience has been a devotion to church. The parishioners at St. Joseph's Roman Catholic Church are predominantly Italian. Msgr. John Servodido, who passed away in March 2009, was a bulwark of the parish and the community and was beloved by all who knew of him. Servodido became pastor of St. Joseph's in 1983 and was known over the years for his dedication to the social needs of the community. Following a military hitch in World War II, he enrolled in St. Joseph's Seminary and was ordained in 1954. "He was God's worker," said a parishioner who was one of "Father John's boys" in the 1950s. "I recognized early in my life what a saint he was," said another. Pictured from left to right, Fr. Michael Allessandro, Servodido, and Stephen Jezycki march along St. Mary's Avenue in celebration of the 100th anniversary of the founding of St. Joseph's Roman Catholic Church in 2002. (Courtesy Staten Island Advance. All rights reserved. Reprinted with permission.)

In 2009, the pastor is Fr. Michael Martine. A native of Prince's Bay, Martine taught at St. Joseph's Seminary for three years. Ordained in 1997, Martine is the parish's fifth pastor and is prepared to carry on the tradition of service to the community established at St. Joseph's. (Author's collection.)

World-renowned artist and sculptor Gregory Perillo was born in Greenwich Village and grew up in Staten Island, where he still resides. His father, an Italian immigrant from Naples, passed along his interest in the American West to young Perillo with stories that had the boy drawing pictures by age five. Perillo attended McGee High School before enlisting in the navy during World War II. After the war, he studied art under the GI bill and with his idol, artist W. R. Leigh. He has traveled the West for over 42 years and lived on Native American reservations. His respect and reverence for Native Americans and their lifestyle is vividly depicted in his work, which is displayed in the Denver Museum of Natural History, the Museum of the North American Indian, and the Butler Institute of American Art. His views of life in the West combine portraits of wildlife and humans on canvas with captivating detail. He has also painted great sports figures, a collection of which is on display at the Butler Institute in Youngstown, Ohio. (Courtesy Gregory Perillo.)

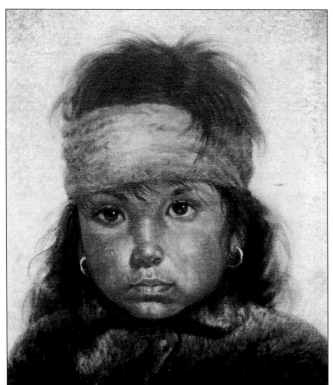

Gregory Perillo loves his work and continues to paint and sculpt every day. He lives by an adage his father passed along: "Success comes from the backbone, not the wishbone." Already the creator of more than 5,000 works of art, he has surpassed the legendary Norman Rockwell in collectable pieces. His painting of an Apache boy reveals the heart and soul of a proud people. (Courtesy Gregory Perillo.)

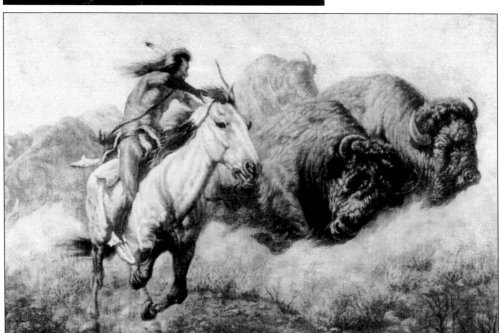

His action scenes go to the soul of his great work. His secret is to put himself in his subject's moccasins. "I like to see the desert the way the Indians see it," he explains. It is little wonder that this Italian American from Staten Island has achieved much deserved international acclaim. *Buffalo Hunt* is a powerful example of his captivating work. (Courtesy Gregory Perillo.)

At 82 years of age, Perillo cannot stop working, nor does he want to. Work like *Dead Aim* continues to splash across his canvasses. (Courtesy Gregory Perillo.)

Like the comedian George Burns, who could not retire because he "was booked," Perillo constantly takes on new projects. A recent one consists of a 40-painting show dedicated to Vietnam veterans, his tribute to unsung heroes. They are "people who deserve not to be forgotten," explains the artist. The show embarked on a 15-state tour that began in Staten Island at Wagner College. "I'm still growing," Perillo said. "I'm more impressionistic and getting better." With God's help, Perillo will be creating munificent works of art for years to come. He is a proud man, proud of his accomplishments, and proud of his heritage. "Every night," he said, "I say my prayers, and I thank God for making me Italian." Of all of his accomplishments in art, Perillo is proudest of being included in *Who's Who in American Art*. His pride is not motivated by the recognition of his work but by the fact that he is among those that he respects the most in his field. "Remington, Russell, Homer," he said, "they were my idols, my inspiration." Undoubtedly, some future artist will revel over being included with Perillo. (Courtesy Gregory Perillo.)

Gregory Perillo's art has gone beyond the American West. The multistate tour of his salute to Vietnam veterans features four individuals whose sacrifices should never go unheralded. Chaplain Francis Cardinal O'Connor and Fr. Vincent Capodanno administered to the sick and dying, while Angel Mendez and Lt. Nick Lia gave their lives in heroic and unselfish sacrifice. As a memorial, a magnificent sculpture of Lia by Gregory Perillo stands majestically on the grounds of Wagner College where Lia once attended. (Courtesy Gregory Perillo.)

Lia gave all that a man can give—for his home, his family, his country—he gave his life. In a place called Quang Tri province, Vietnam, Lia died on February 2, 1968, killed in a discharge of a claymore mine. Lia was serving his second tour of duty after being wounded by shrapnel from a rocket-propelled grenade. He was buried with military honors at St. Mary's Cemetery in Grasmere. A football star at Curtis High School and Wagner College, he was a key member of Wagner's undefeated 1964 team and captain of the 1965 squad. A plaque at the memorial statue at Wagner reads, "U.S. Marine 1st Lt. Nicholas Anthony Lia, Wagner College class of 1966, dedicated his life to the service of his country in both war and peace." (Courtesy Wagner College 1966 Memorial.)

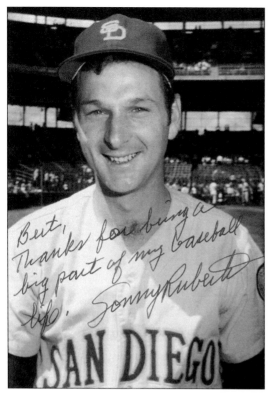

John "Sonny" Ruberto was a catcher with a great arm and a savvy for the game of baseball. A graduate of Curtis High School and a two time all-city catcher, Ruberto played for 10 seasons in the minor leagues before getting to the majors with the San Diego Padres in 1969. He was with the 1972 National League champion Cincinnati Reds. Ruberto also managed in the minors and was a coach with the St. Louis Cardinals. He has been a member of the Staten Island Sports Hall of Fame since 2007. (Courtesy Staten Island Sports Hall of Fame.)

In 1964, Staten Island's Mid-Island Little League team won the Little League World Series in Williamsport, Pennsylvania. Coached by Bill Rogers and Bill Klee, the team was undefeated in 13 straight games before winning the big one before a crowd of 25,000 and a national television audience. One of the stars of the game was Dan Yaccarino, who pitched a no-hit game and hit a home run in the 4-0 victory over Mexico. (Courtesy Staten Island Sports Hall of Fame.)

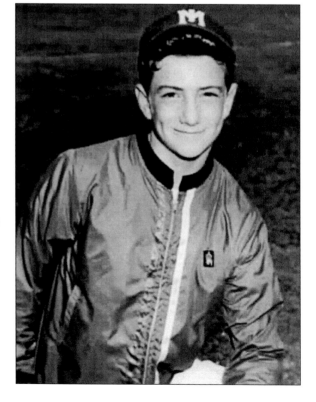

Fr. Vincent Capodanno attended Curtis High School and Fordham University before entering the seminary. He served as a Maryknoll missionary in Taiwan in the late 1950s prior to volunteering for service in Vietnam. (Courtesy Al Lambert.)

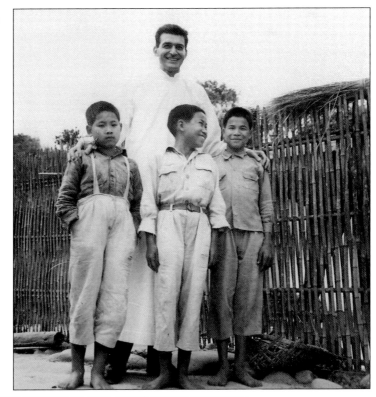

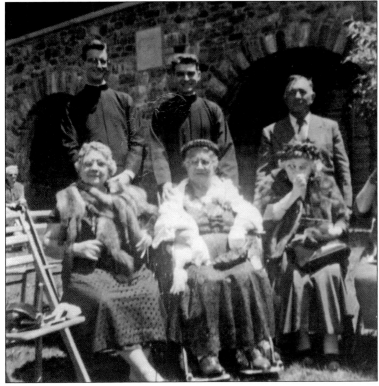

This is a family photograph of Capodanno (standing, center) with an unidentified priest (left) and Jerry Cibella (right). Seated from left to right are Anna Lambert, Capodanno's aunt and godmother; his mother, Rachel Capodanno; and Jenny Cibella, Capodanno's aunt. The three ladies are sisters. (Courtesy Al Lambert.)

Fr. Vincent Capodanno was a Catholic chaplain assigned to the U.S. Marine Corps during Operation Swift in the Vietnam War. "Mike" Company, 3rd Battalion, 5th Marines, was outnumbered and being hit hard by a massive enemy force. Capodanno left a position of relative security to attend to the wounded and dying. As he crawled from man to man aiding and comforting, he was struck by shrapnel. Patched up by medics, he continued unrelentingly until hit by automatic weapons fire. At 7:30 a.m. on September 4, 1967, Capodanno gave his life in the cause of freedom. Awarded the Medal of Honor for conspicuous gallantry, he has been cited for possible sainthood by the Catholic Church. On May 12, 2002, the cause for canonization was officially opened. He is now referred to as a "servant of God," the first step towards canonization. (Courtesy Al Lambert.)

Six

FROM THE 1990S INTO THE NEW MILLENNIUM

The battle-hardened, tough-as-nails marine has been linked with the delicate and beautiful red rose. It was in 1778 during the Revolutionary War that the rose was dedicated to those Marines who died for their country. The tradition was indelibly ensconced when the Marines attacked the Germans in the trenches at Beleau Wood, France, in World War I. Grateful French villagers planted roses at the graves of the fallen Marines. Vincent Endrom (seated) an Italian American, served on Guam, Hawaii, and in China and Korea. Sean Torres (standing) served during the Desert Storm conflict. (Author's collection.)

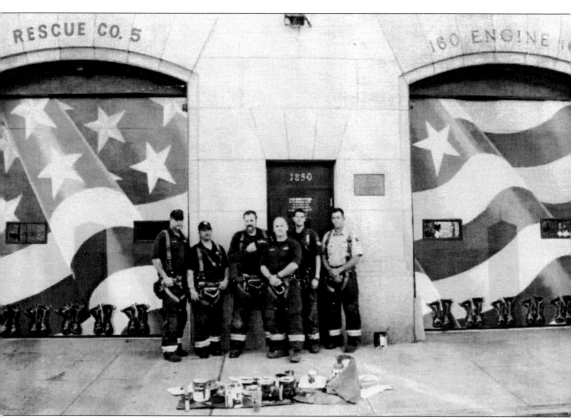

The tragic morning of September 11, 2001, brought people to the acme of courage and self-sacrifice. Firefighters from Staten Island's Rescue 5 in Concord responded swiftly and efficiently. Lt. Chuck Margiotta was off duty, and he drove to the nearest fire station, Rescue 5 on Clove Road. Capt. Louis Modaferri was in command, and he, also off duty, drove to the station as soon as he heard the news of the attacks. Both men were lost that day. The photograph of Rescue 5 shows the mural painted by Staten Island artist Scott LoBaido honoring the 11 heroes who died from that company. Note the 11 empty pairs of boots in the foreground. The total loss of Staten Islanders on September 11 was 235; 78 were firefighters, 2 were port authority officers, and 1 was a city policeman. There were 154 civilians lost. At a memorial service at St. Clare's Church in Great Kills, it was announced that Modaferri was posthumously promoted to battalion commander. The crowd stood up and applauded. (Courtesy Staten Island Advance, 2008. All rights reserved. Reprinted with permission.)

In 2001, the minor league Brooklyn Cyclones re-created professional baseball in the New York area, and Gary Perone of New Springville was there from the start. Director of new business development, Perone is also an associate scout for the parent organization, the New York Mets. He has seen promising young players, like Angel Pagan, Bobby Parnell, and Dan Murphy, get their starts with the Cyclones. Perone earned a degree in business and communications from St. Francis College. (Author's collection.)

Frank Menechino is a native of New Springville, Staten Island, and the current batting instructor of the Eastern League Trenton Thunder. For Menechino, it is the start of a new career after seven seasons as a Major League Baseball player. A graduate of Susan Wagner High School, he was drafted out of the University of Alabama in 1993 by the Chicago White Sox. "It's a challenge," Menechino says of his new job for which his experience will be a big boost. In 2001, he also played for the American League West division winners, the Oakland A's. (Courtesy Staten Island Advance, 2004. All rights reserved. Reprinted with permission.)

Mike Siani was a football star at Curtis High School and Villanova University. He was drafted by the Oakland Raiders in 1972. Siani starred for nine seasons in the National Football League for Oakland and the Baltimore Colts. (Courtesy Staten Island Sports Hall of Fame.)

In December 1995, the Staten Island Sports Hall of Fame held its first induction ceremony at the College of Staten Island. Of the 11 initial inductees, two were of Italian descent: Sal Somma and Mike Siani. It was the vision and perseverance of Somma that was most responsible for this enduring memorial to the island's greatest athletes. It was fitting that Somma, a football star at Curtis High School and New York University, should have had his plaque unveiled first. His greatest achievements came as a distinguished high school football coach for 29 years. (Courtesy Staten Island Sports Hall of Fame.)

Al Lambert is proud of his offspring. He teamed up with daughter Laura to sing, and the result was the CD *The Lamberts Live*. At the age of eight, Laura played the lead in the Seaview Playwright's production of *The Wizard of Oz*. She has gone from there to singing at Snug Harbor and the I Love New York Festival. She holds a bachelor's degree in English literature and currently sings with the Al Lambert and the Corporation band. (Courtesy Al Lambert.)

From Diego Ferrara to Albert Charles Lambert spans four generations of family history. From Acoma, Sicily, to Staten Island, New York, stretches over 3,000 miles of ocean. From the automobile business to Counsel to the President of the United States expands a strata of equal distance. Lambert is a graduate of Monsignor Farrell High School and New York University. He earned his law degree at Harvard Law School and went to work for a Washington, D.C., law firm before being selected as associate counsel to Pres. George W. Bush. (Courtesy Al Lambert.)

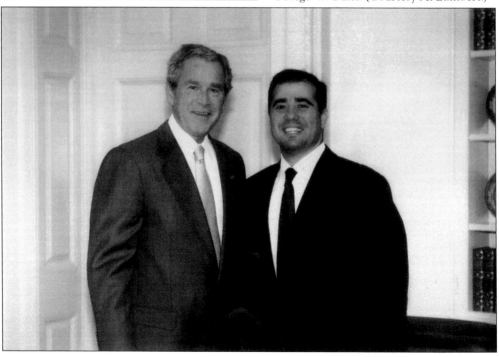

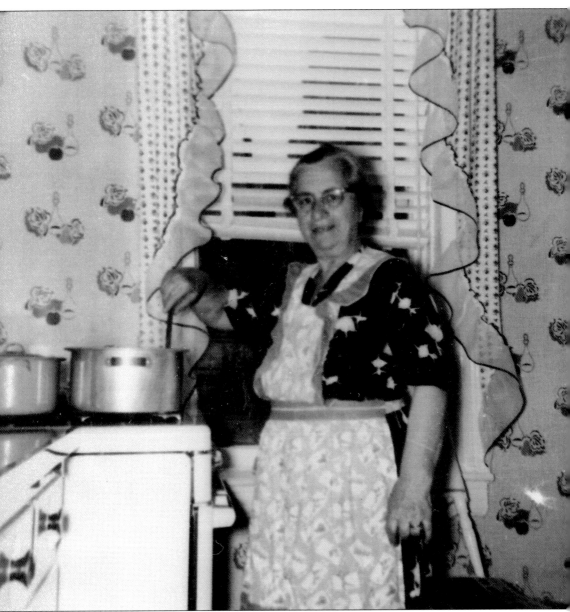

Food is more than a staple for Italians; it is a way of life. Even today's generation can recall mama or grandma making homemade ravioli by spreading the dough on a bedspread covered by a sheet and cutting the ravioli with the rim of a juice glass. There was never any waste either. The scraps of dough would be rolled into pasta called cavatelli. At Sunday afternoon meals, the man of the house sat at the head of the table with a bottle of red wine resting comfortably at his feet. The evolution of family life has changed some things—ravioli and manicotti are purchased at Italian Salamari stores—but the core of the Sunday dinner remains intact in most Italian American homes. Every Italian family has a photograph like this one in the family album. Mama, grandma, or nana are never far away from the kitchen. Pictured is Mary Mele in the 1940s. (Author's collection.)

Specialty stores that feature Italian delicacies thrive on Staten Island. Provolone and mozzarella (made fresh daily) are among dozens of cheeses available to the clientele of Top Tomato, one of the most popular and busiest of island stores marketing a wide range of Italian-oriented cuisine. (Author's collection.)

Cold cuts like prosciutto and cappicola are endlessly sliced during the hectic store hours that keep the staff busy preparing food and stocking shelves. (Author's collection.)

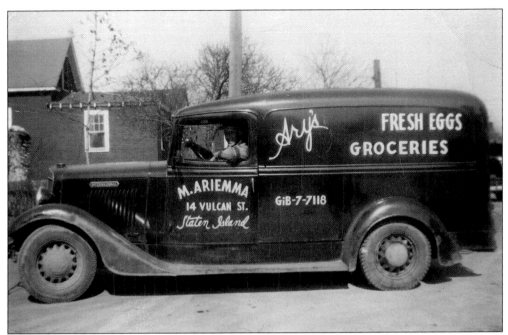

Mario Ariemma pedaled vegetables from a truck as long ago as 1946 before opening a store on Hylan Boulevard and Buel Avenue in 1953. His son Mario Jr. followed his father into the business, and he is still at it after 35 years. He remembers Buel Avenue as a dirt road and playing stickball on Hylan Boulevard. "All good things happened to me in this store," Mario Jr. said, "but it takes its toll. I have four children, the oldest is 21 and I never had the time to take them to Disneyland." The result was customer satisfaction and a reliable neighborhood Italian deli. (Courtesy Mario Ariemma.)

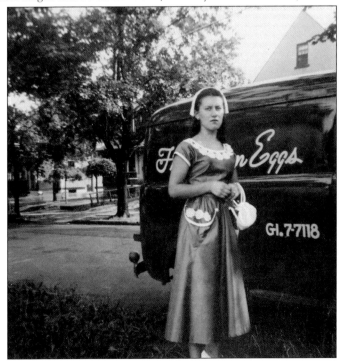

Mom of Mario Jr. and wife of Mario Sr., Ruth Ariemma was there in the early days to help in the store and to run the family at home during the long, tiring store hours. (Courtesy Mario Ariemma.)

The island is dotted with fine Italian restaurants, and no matter the location, one is probably just a block or two away from a great Italian meal. Carol Carollo (left) and Angela Mascia (right) enjoy a dish of spaghetti at Italianissimo restaurant in Arrocar. (Courtesy Stephanie Vierno.)

A popular festival for Italians is Carnevale, a pre-Lenten celebration held each February. Brioso's Restaurant on New Dorp Lane keeps tradition alive with a festive evening, serving only Venetian fare. Ladies wearing Carnevale masks from left to right are Diana Basic, Stephanie Vierno, and Donna Scalice. (Courtesy Stephanie Vierno.)

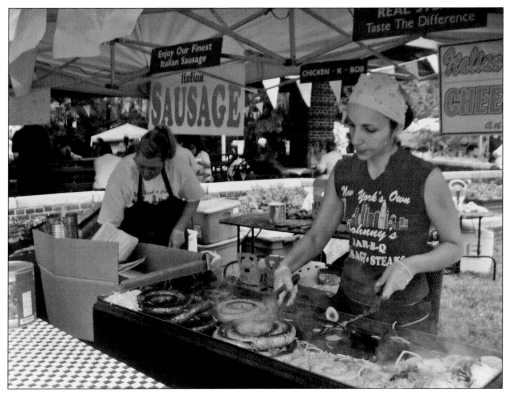

The annual Festa Italiano was held in June and presented by the Staten Island Zoological Society and the South Shore Rotary Club in cooperation with the Garibaldi-Meucci Museum. In keeping with the code words of Italian festivals, there was food, music, rides, exhibits, games, and tournaments. Of course, food is the major draw at festivals, with zeppoli as well as sausage and peppers getting the most attention. Maria Germino (right) and Sarah Grove (left) serve up great sandwiches to lines of hungry festivalgoers. (Author's collection.)

The Feola family is pictured here, from left to right, Carmine, Carmine Jr. (age 12), Linda, and Mia (age 4). They are enjoying a sausage and peppers break during the festivities. (Author's collection.)

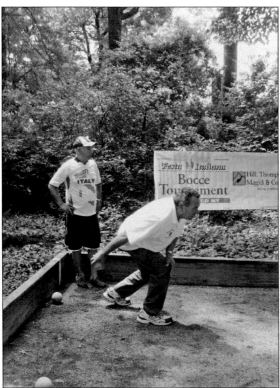

An Italian festival without a game of bocce would be nearly as disastrous as running out of sausage and peppers. A veteran bocce player sizes up his target and gets ready to bowl. (Author's collection.)

Some form of the game of bocce was played in the Roman Empire. Although popular in many parts of the world, bocce developed into its present form in Italy and came to America with the immigrants. One can enter a bocce tournament at Festa Italiano to round out a fun day. (Author's collection.)

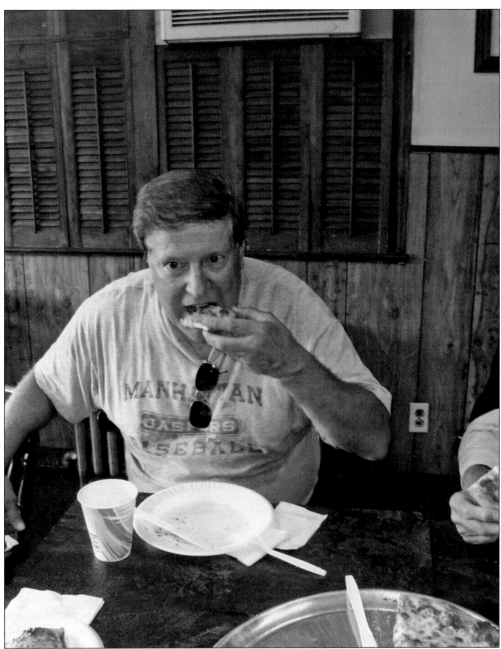

Of course, the single most identifiable food associated with Italians is pizza. In Naples in the 16th century, a flatbread was referred to as pizza. The ingredients varied until 1889, when chef Raffaele Esposito created the pizza margherita in honor of the queen consort of Italy. He garnished it with tomatoes, mozzarella cheese, and basil to represent the colors of the Italian flag. It is believed that Antica Pizzeria, Port' Alba in Naples was the city's first pizzeria. Pizza came to the United States with the arrival of Italian immigrants in the late 19th century. It is also believed that the first pizzeria in America was founded by Gennaro Lombardi in Manhattan's Little Italy in 1905. Pizza even has its own month, as October is declared national pizza month. Here Roy Larezzo engulfs a slice at Pizza D'Oro on Victory Boulevard in Bulls Head. (Author's collection.)

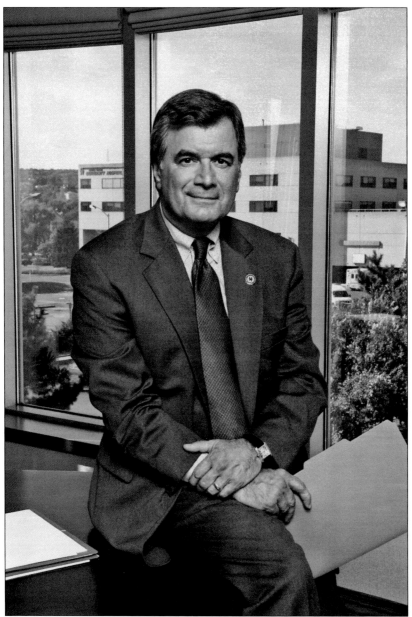

Staten Island University Hospital is a major teaching hospital and the sixth largest in New York City. The hospital is Staten Island's largest employer, and 85 percent of the hospital's employees live on Staten Island. Anthony C. Ferreri has been the hospital's president and chief executive officer since August 2003. Before joining the hospital, Ferreri served the same role at Metrotemp Services Company. A lifelong resident of Staten Island, he earned a bachelor of arts degree from Wagner College and a master of science degree in human resources and industrial relations from Rutgers University. Ferrari's grandparents emigrated from Sicily and Abruzzi, Italy, and he grew up in a typically Italian household. "We had fresh meat sauce every Sunday," he recalled, "and macaroni again on Tuesday and Thursday." The Catholic Church had a ban on eating meat on Fridays, "so we had macaroni and butter on Friday. Pasta four times a week." (Courtesy Staten Island University Hospital.)

The building on Seaview Avenue was completed in 1979. In April 2009, the new Elizabeth A. Connelly Emergency Room and Trauma Center and the Regina M. McGinn, MD Education Center were dedicated. (Courtesy Staten Island University Hospital.)

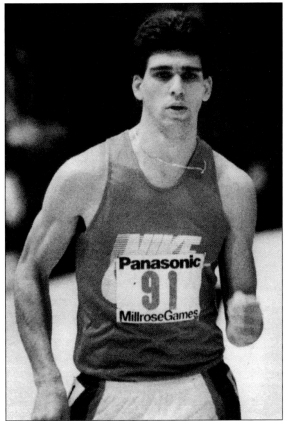

Charlie Marsala was a runner for New Dorp High School, where he ran a 4 minute, 11.7 second mile. At Indiana University, he was an All-American in the mile and 1,500 meters and a member of the U.S. National team. He later coached at Wagner College. In Boston in 1991, Marsala ran a 3 minute, 58.7 second mile; the only Staten Islander ever to break the monumental four minute barrier. Marsala was elected to the Staten Island Sports Hall of Fame in 2002. (Courtesy Staten Island Sports Hall of Fame.)

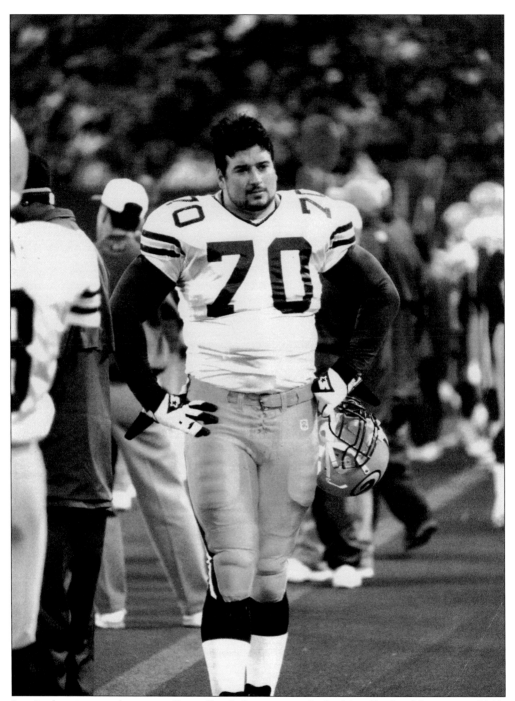

Joe Andruzzi was a three-time Super Bowl champion with the New England Patriots in 2002, 2004, and 2005. The 315-pound offensive guard was a Division II All-American at Southern Connecticut State University and played 10 seasons in the National Football League with the Green Bay Packers, Patriots, and Cleveland Browns. Andruzzi was installed in the Staten Island Sports Hall of Fame in 2007. His career was cut short by cancer, and he remains a symbol of courage and hope to fans and friends. (Courtesy Staten Island Sports Hall of Fame.)

Mike Azzara has been a respected columnist for the *Staten Island Advance* since 1963. A native Staten Islander, Azzara grew up in South Beach and is a graduate of New Dorp High School and Wagner College. His "Memories" column has pulled at the hearts and minds of so many readers who revel in nostalgic recollections of past times. James Barrie once wrote, "God gave us our memories so that we might have roses in December." Azzara keeps the rose bushes watered, as he jolts the archives of one's mind and does it in splendored style. (Courtesy Staten Island Advance, 1998. All rights reserved. Reprinted with permission.)

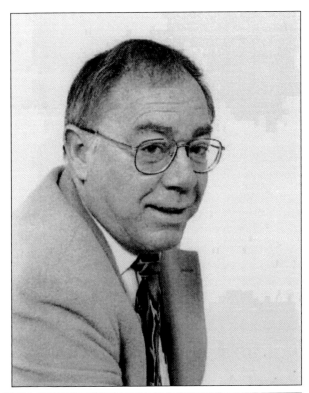

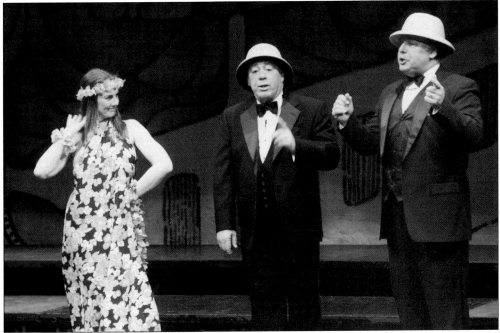

From left to right are Barbara Weir, Mike Azzara, and Tom Tyburczy performing "Road to Morocco" in the South Shore Rotary Club's *Hooray for Hollywood* production at the College of Staten Island's Williamson Theater. (Courtesy Staten Island Advance. All rights reserved. Reprinted with permission.)

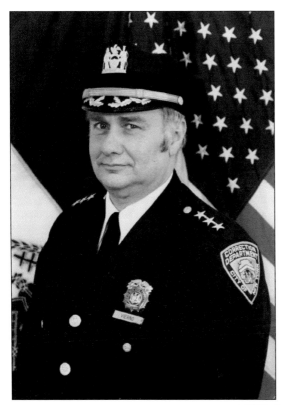

George Vierno grew up in West Brighton, attended Port Richmond High School, and spent some youthful hours ushering at the Empire Theater on Richmond Terrace. Vierno joined the New York City Corrections Department in 1961 and retired in 1990 as chief of the department. However, it was not his rank that put him in the vanguard of great men, it was the respect and esteem others held for him. After his premature passing at age 50, Mayor David Dinkins called Vierno, "a consummate professional and a friend to all who knew him." (Courtesy Stephanie Vierno.)

Judge Philip S. Straniere is a native Staten Islander who graduated from Curtis High School. Foregoing his dream to play center field for the New York Yankees, he turned to the law. Straniere was elected to the civil court in 1996 and in 2004 was named acting justice of the New York State Supreme Court. Described as a people's judge and a lawyer's judge, Straniere is a man of good education, good humor, and with a devotion to family and religion. He is supervising judge of Richmond County. (Courtesy Staten Island Advance, 2002. All rights reserved. Reprinted with permission.)

Giuseppe Taormina, "the King of High C," was born in Palermo, Sicily, where he began voice training at an early age. After arriving in America, he was accepted into the Young Artists Program of the Metropolitan Opera Company. A Staten Island resident, Taormina has performed throughout the world and is the recipient of the prestigious honor of Necklace Knight, Cavaliere di Collona. He has appeared with the Philadelphia Opera Company, at the Waldorf Astoria Hotel in New York, and in the world-renowned Carnegie Hall. Taormina's magnificent voice is a tribute to his Italian heritage and expresses his passion for music. (Courtesy Giuseppe Taormina.)

The indelible link between Italians and music stems from a profound legacy, including Enrico Caruso of Naples, Luciano Pavarotti of Modena, Giuseppe Di Stefano from Sicily, and Mario Lanza from South Philadelphia. The heritage thrives on Staten Island through the Riverside Opera Company conducted by maestro Alan Aurelia. The maestro is an Italian American living on Staten Island whose grandfather emigrated from Avelino, Italy. Aurelia has performed for Pope John Paul II and England's Queen Mother, as well as at Carnegie Hall and the Festival Sinfonico di Massa in Italy. The *Staten Island Advance* noted, "His concerts strike a multicultural chord." The Richmond County Orchestra, of which Aurelia is music director, has performed at the Guggenheim Museum and received a rave review in the *New York Times*. (Courtesy Alan Aurelia.)

Carmine Dominick Giovinazzo was born and raised in Port Richmond, Staten Island. He moved to Los Angeles in 1997 in order to pursue an acting career. Since that time, he has appeared in a number of films and television shows. He is currently cast as forensic scientist Danny Messer on the hit television series *CSI: NY*. (Courtesy Nancy Giovinazzo.)

A fine athlete, Giovinazzo played baseball at Port Richmond High School and was an outstanding shortstop at Wagner College. Touted by the Chicago Cubs as a possible draft choice, he suffered a back injury that ended his hopes for a professional baseball career. Still active athletically, Giovinazzo has played in the Pro-Am Golf tournament at Pebble Beach. (Courtesy Nancy Giovinazzo.)

One of the great Italian American traditions is the celebration of Columbus Day. Staten Island held its 19th-annual parade in New Dorp on October 4, 2009. Featured was a Staten Island council of the Knights of Columbus. A worldwide Catholic fraternal service organization named in honor of Christopher Columbus, the Knights boast more than 1.7 million members. Dedicated to the principles of charity, unity, fraternity, and patriotism, the order has been responsible for $1.1 billion in charitable contributions over the past 10 years. (Author's collection.)

The music of the tarantella dance is probably the most recognizable in Italian folklore. Featured by mandolin music, it has a happy, rollicking sound. An Italian wedding is probably not legally recognized until the tarantella is danced at the reception. Dancers form a large circle going clockwise and then change direction to counterclockwise. Versions vary from region to region, with the Napoletana (Naples) version heard most frequently and the Sicilian and Calabrese versions variations following the same classic melody. A typical Italian wedding scene like this one includes the tarantella. (Courtesy Stephanie Vierno.)

Sr. Mary Joseph Deasaro was a resident at the home of the Presentation Sisters in Annadale. She reached everyone who knew her with her kindness and sense of humor, including the students of St. Teresa's School in Castleton Corners, where she also served as principal. (Courtesy Presentation Sisters.)

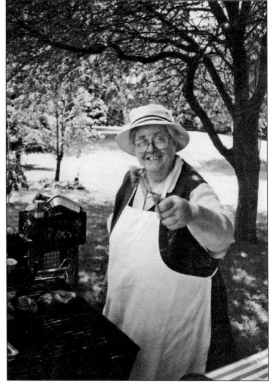

There are sacrifices in the religious life, and some may even seem trivial. Being brought up in an Italian household and then living with a gaggle of Irish nuns, Deasaro needed to get used to a different diet. "These people eat nothing but potatoes," she once complained good naturedly, "I'm used to real food." Highly respected, she is noted for the authority in her voice. She flipped hamburgers at holiday barbeques at the mother house, and when she told someone to "sit down and eat," they sat down and ate. Deasaro passed away in 2001. (Courtesy Presentation Sisters.)

Seven

YESTERDAY, TODAY, AND TOMORROW

The future lies in the past. Thus knowledge of history is essential in the development of a strong and positive future. Education is the source of the development of that future. Dr. Thomas Matteo is an associate professor at St. Peter's College in Jersey City. Born in Brooklyn in 1948, Matteo has been a Staten Island resident since 1979. In 2007, Matteo was appointed Staten Island's official borough historian. (Courtesy Dr. Thomas Matteo.)

The history of Staten Island University Hospital is woven into the tapestry of the borough itself. The modern facility sprang from a dispensary at the corner of Bay Street and Union Place in Stapleton run by the Richmond County Medical Society. In 1887, new quarters were constructed on six acres of land on Castleton Avenue in New Brighten. The Samuel Russell Smith Infirmary, known as "the Castle," opened its first training school for nurses in 1894. (Courtesy Staten Island University Hospital.)

Named Staten Island Hospital, the community was served by the facility and its early ambulances. The hospital is pictured here around 1930. (Courtesy Staten Island University Hospital.)

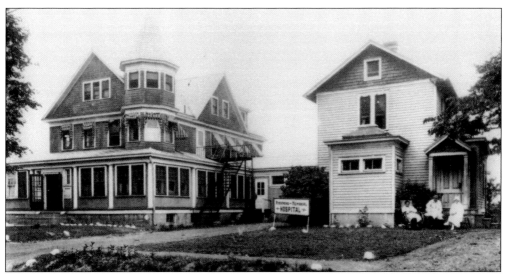

The original Richmond Memorial Hospital (shown in 1919) was set up in two farmhouses on the southern most portion of the present property on Seguine Avenue. Founded in honor of the heroes of World War I, it was in 1987 that Richmond Memorial Hospital merged with Staten Island Hospital, creating what is today known as Staten Island University Hospital. (Courtesy Staten Island University Hospital.)

Dr. Theodore Strange, an Italian American, is a graduate of Xaverian High School and earned his undergraduate degree, magna cum laude, from Manhattan College. Strange received his medical degree from State University of New York Downstate. He is currently associate director of medicine and vice president of medical operations at the South Site of Staten Island University Hospital. A marathon runner, Strange has competed in 13 New York City Marathons and one Boston Marathon. He and his wife of 24 years, the former Valerie Pantaleone, live in Tottenville and have four children. (Courtesy Staten Island University Hospital.)

There is an informal gathering of retirees that meets each weekday morning at a very informal place—the food court at the Staten Island Mall. The men are all retired Italian American police officers. Most worked together at the 120 Precinct in St. George and retain their friendship over coffee and old stories. From left to right are John Feis, Don Vinci, Frank Polizzi, Tony DeNatale, Rich Commesso, and Joe Manfra. (Author's collection.)

Judge Philip G. Minardo received his doctorate from St. John's University School of Law. He served as assistant district attorney in Richmond County and as special counsel to state senator John Marchi. Elected justice of the supreme court in 1955, in 2009 he was named county administrative judge for the state supreme court. (Courtesy Staten Island Advance, 2009. All rights reserved. Reprinted by permission.)

Staten Island's Italian Americans go about their everyday routine in an efficient, unassuming way. Joseph Fecci is an ambitious young man who owns the Annadale Auto Spa. He is a hands-on owner, at work every day making sure his customers' cars are clean. (Author's collection.)

Mike Lanza (right), pictured with son Andrew, owns and operates Legends Sporting Goods in Pleasant Plains. An old athlete himself, Lanza is there to help his customers with a purchase or just to talk sports. (Author's collection.)

Roman Catholic mass has held a priority place in Italian culture for centuries. Following Sunday mass at St. Joseph-St. Thomas Roman Catholic Church in Pleasant Plains, Fr. John Palatucci greets parishioners Peter, Carol, and Mathew Izzo. Mathew is an altar server at mass. The South Shore of Staten Island contains the largest concentration of Italian Americans on the Island. An all-Italian mass is held at the parish each week. (Author's collection.)

There is music in the Italian soul, but there is laughter in the Italian heart. "Italians," wrote Stendhal (Marie-Henri Beyle), "had mastered the art of being happy." Laughter is a vital part of everyday life. New Jersey comic "Uncle" Floyd Vivino visits Staten Island to appear before audiences that are predominately Italian. Italians love to laugh at themselves and familiar scenarios. Vivino (left) is pictured with Staten Island fan Andrew Mele Jr. (Author's collection.)

John Potenza is a hang-in-there guy. The host of cable television's *Late Night with Johnny P.*, Potenza also promotes his own band, NYB. The Prince's Bay resident is also an editor of music videos and a producer. His Italian heritage has served him well, as the hard working, dedicated young man continues to persevere and achieve. (Courtesy John Potenza.)

Dr. Richard Guarasci is the 18th president of Wagner College. He is a professor of political science and teaches democracy, citizenship and American diversity. A leader in higher education, Guarasci has been cited for Staten Island public service. He holds a doctorate in political science from Indiana University and is cochairman of the Da Vinci Society of Wagner College. Pictured from left to right are Guarasci, Rosanna Scotto of Fox News, and former borough president Ralph Lamberti. (Courtesy Staten Island Advance, 2006. All rights reserved. Reprinted with permission.)

For 20 years, Prof. Michael Christiano has taught sociology and criminal justice at Wagner College. He also teached at the College of Staten Island (CSI). He received his bachelor's degree at St. Francis College in Brooklyn, where he began teaching, and a master's degree in criminal justice at John Jay College in Manhattan. "Some of my students think my teaching is criminal," Christiano said, displaying a sense of humor that has surely been a conduit to his many students over the years. (Author's collection.)

John Fodera has been the principal of St. Peter's Boys High School since 1990. Fodera was a student at St. Peter's and received a master's degree in political science from Georgetown University. In the profession since 1968, Fodera taught history at St. Peters before becoming school principal. More than 50 percent of the student body of 700 is Italian American. There is a sense of heritage among these students, according to the principal. "It exists big time." There is a three-year Italian language course and a very active Italian Heritage Club. Fodera is seen with 2008 graduate John Dowd. Dowd was a high school football star and attends the U.S. Naval Academy at Annapolis, Maryland. (Courtesy John Fodera.)

Young Italian Americans demonstrate a knowledge and interest in their heritage. Cristina LoNano Franz is a seventh-grade student in the Genesis Program at Xaverian High School. The theme for the school history fair was "An Individual in History Who Made a Difference." It is revealing that Franz chose to write about Giuseppe Garibaldi and his contribution to the unification of Italy because of her Italian heritage. In the photograph, she is wearing the team shirt of the Palermo soccer team. (Courtesy James LoNano.)

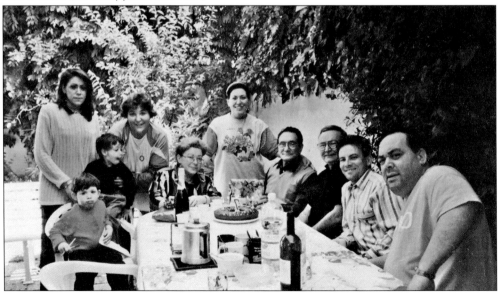

If there is one constant linking past, present, and future for Italians, it is family. A person not of Italian heritage marrying an Italian may find that they have married an entire family, and every Sunday is dedicated to family outings. Here the Ferraiuolo family enjoys a spring afternoon in the backyard. (Courtesy Frank Ferraiuolo.)

Perseverance and diligence paid off for Alexandra Love when she became the eighth-grade valedictorian of St. Joseph-St. Thomas School in Pleasant Plains. When notified of the news, Love said she "stared, yelled, and cried," and then called everyone she knew. Love has learned the meaning of hard work, a vestige of a steadfast heritage. "I'm three-quarters Italian," she said. In addition to giving the valedictorian address at the graduation exercises, Love garnered nine awards, including the Patriotic Service award from the Knights of Columbus for her essay, "Proud to be a Catholic American," and the Student Achievement award for outstanding performance and school leadership, given by the Office of the Borough President. She began attending St. Joseph-by-the-Sea High School as a member of the scholars program in September 2009. (Courtesy Christine Love.)

Frederick Varone attended St. Peter's Boys High School with a full scholarship and graduated as class valedictorian with a grade point average of 98.7. Always an achiever of the highest caliber, Varone was a member of the National Honor Society and vice president of the student council. He played soccer, was a member of the varsity wrestling team, and took a number of college classes in his senior year, including English, calculus, and advanced placement biology. Varone gave his speech as valedictorian and received the general excellence, English, and perfect attendance awards. Of all 10 colleges that he applied to, he was offered full or partial scholarships to every one. Varone began attending Hofstra University on a presidential scholarship in September 2009, as a member of the Hofstra University Honors College. Noting the young people represented within these pages seems to indicate that the future is in very able hands. Good wishes and God's blessing to them all. (Courtesy Varone family.)

Italians have a long and grand heritage to look back upon, including Galileo, Michelangelo, Christopher Columbus, Giovanni da Verrazzano, Enrico Fermi, Enrico Caruso, and "Joltin'" Joe DiMaggio. There are also the mail carriers, the steamfitters, the shoemakers, the printers, the gardeners, the lawyers, the judges, and business leaders. It is to this great heritage that Italian Americans can look and future generations can flourish by acknowledging those "rays of hope" spawned by the legacy of a great people. In his book *The Children of Columbus*, Erik Amfitheatraf wrote that immigrants "were usually outsiders struggling against great odds, and the best of them were brave, beautiful human beings full of warmth, and a large hearted concern for humanity . . . this is the real tradition of the Italian American." *Buona fortuna amici e famiglia*. (Courtesy Christine Love.)

Discover Thousands of Local History Books Featuring Millions of Vintage Images

Arcadia Publishing, the leading local history publisher in the United States, is committed to making history accessible and meaningful through publishing books that celebrate and preserve the heritage of America's people and places.

Find more books like this at
www.arcadiapublishing.com

Search for your hometown history, your old stomping grounds, and even your favorite sports team.

Consistent with our mission to preserve history on a local level, this book was printed in South Carolina on American-made paper and manufactured entirely in the United States. Products carrying the accredited Forest Stewardship Council (FSC) label are printed on 100 percent FSC-certified paper.

MADE IN THE